Creative Calligraphy

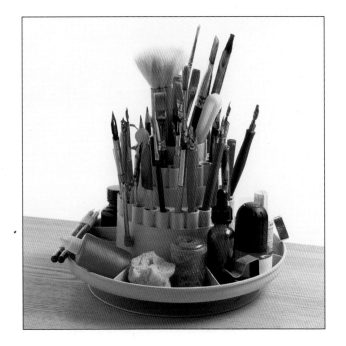

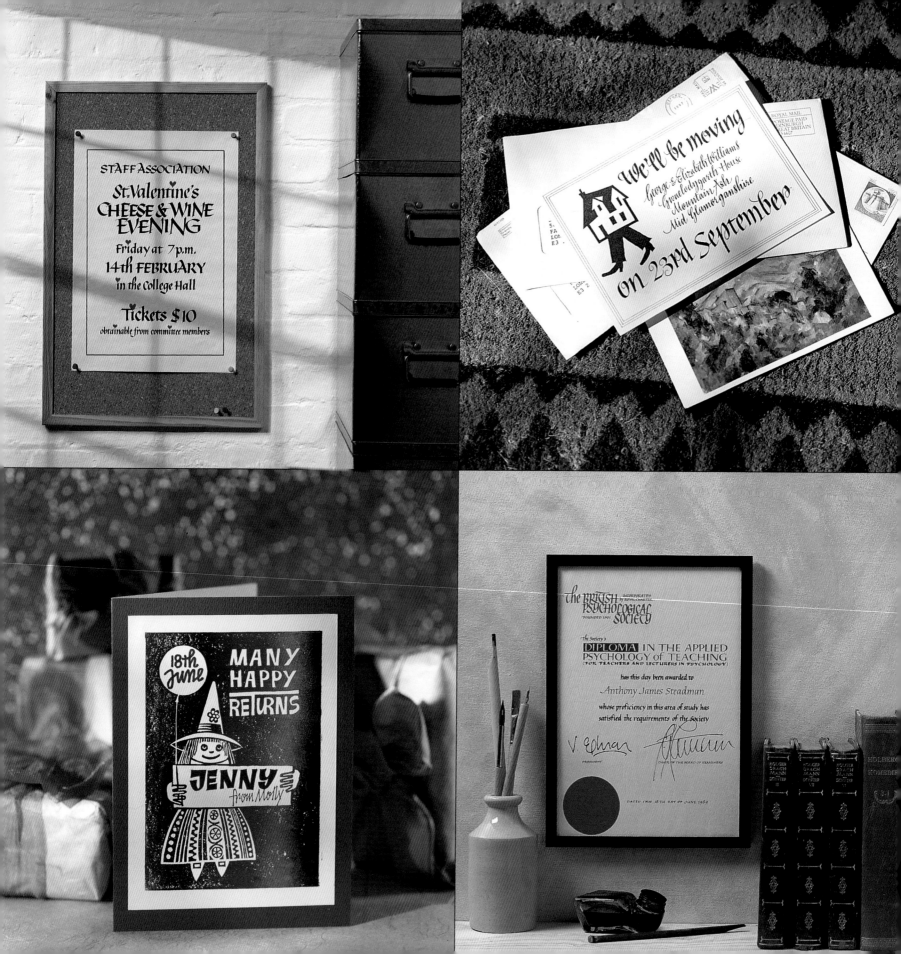

Creative Calligraphy

John Smith

Photographs by John Freeman

LORENZ BOOKS

For Jenny, Mark and Alison

This edition first published in 1998 by Lorenz Books
27 West 20th Street, New York, NY 10011

Lorenz Books are available for bulk purchase for sales promotion and for
premium use. For details, write or call the sales director:
Lorenz Books, 27 West 20th Street, New York, NY 10011; (800) 354-9657

© Anness Publishing Limited 1998

Lorenz Books is an imprint of Anness Publishing Limited

ISBN 1 85967 662 6

Publisher: Joanna Lorenz
Editor: Fiona Eaton
Designer: Alan Marshall
Photographer: John Freeman

Printed in Hong Kong

1 3 5 7 9 10 8 6 4 2

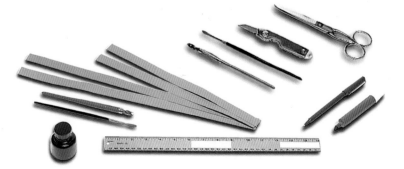

CONTENTS

INTRODUCTION

Most would-be calligraphers who pick up this book will already have an interest in this immensely absorbing and satisfying craft. If your wish to write beautifully is sufficiently compelling, you will at least have your hand placed on the rung of an enthralling ladder.

The word "calligraphy" is derived from the Greek and means "beautiful writing", and that is the concern and expectation of this book. The first section presents a comprehensive step-by-step introduction to writing with the square-edged pen. It sets out the basic tools you will need, suggests others to collect, provides a rich variety of alphabets from which to work and familiarizes you with the terminology of calligraphy. The second section consists of a range of projects, using a wide variety of techniques that you will be able to apply not just to these projects but to many more besides.

The subject of calligraphy holds an incurable fascination. It is meditative, therapeutic and expressive, exquisitely marrying fine words with beautiful writing· allow yourself to be mesmerized!

Do not be deterred if you think you lack natural artistic talent – although this is beneficial, calligraphy is a skill that can be learned. As your confidence increases, you will develop your own personal style of writing and, with experience, come to recognize the style of others. When you study the wonderful work of contemporary lettering artists, remember that they too were once beginners. Be patient and persevere: your acquaintance with the dance of the pen is bound to be rewarding. Calligraphy is a pursuit to treasure.

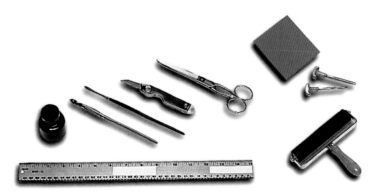

Opposite: Picture alphabet of experimental lettering.

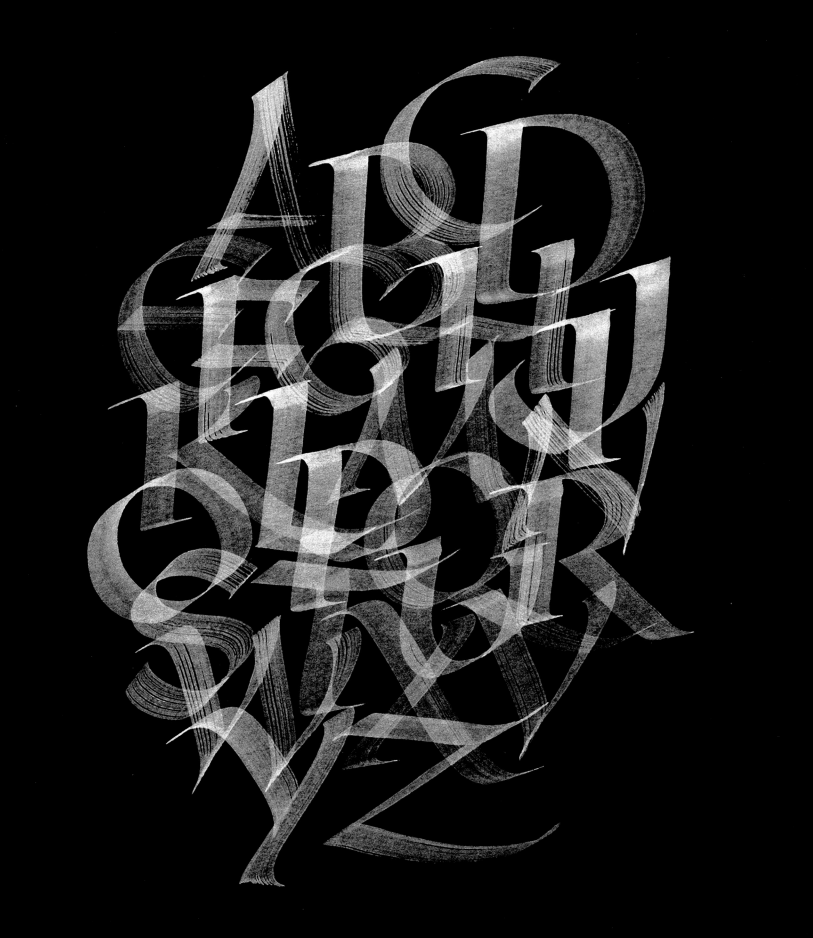

Tools and Materials

A list of the materials a calligrapher endeavour collect within an arm's length of his working surface could be as long as that arm itself! The only items you really need to begin calligraphy are pen, paper and ink, but obviously you may want to build up a collection of materials.

Pencils

HB, H or F pencils are probably the most useful (F is firm and stands between HB and H in blackness). For drawing guidelines, sharpen a pencil at a shallow angle and refine the point further by a shallow rotating movement on rough paper. Use a white pencil on dark paper.

Erasers

Buy the very best soft white eraser available.

Pen holders and nibs

A dip pen consists of a pen holder and a nib. Mitchell square-cut nibs (left-oblique for the left-hander) vary in size from 0 (the largest) to 6 (the smallest). These nibs will accommodate a small golden slip-on reservoir to control the flow of ink, but this is not always used on very small nibs. The protective grease on new nibs should be wiped away so that they do not resist water-based ink or gouache. Flexible, pointed nibs (sometimes called Post Office pens because they used to be left on the counters) are used for Copperplate writing, for sharpening up letters such as Versals and for drawing. Round-barrel pen holders are more comfortable than triangular ones. Some pen holders hold the nib in place with a lever.

Ruler

A Perspex 50cm/20in ruler is very useful. It is useful to have an opaque strip along its ruling edge and marked lines parallel to the edge. A metal ruler is used for measuring, lining up and as a straight edge when trimming with a craft knife.

Brushes

Sable-hair brushes are best for lettering that requires a pointed serif or fine line. Use cheaper brushes for mixing colour or filling the pen. Chisel-edged synthetic brushes are ideal for larger square-edged lettering. A pointed synthetic brush is needed for masking fluid and a small hog-hair brush for cleaning pens and reservoirs.

Inks and paints

Bottled ink
Ink must be water-based. If it does not flow easily, add a few drops of distilled water and always shake the bottle. A good test of any medium is how much it smudges when the guidelines are erased.

Stick ink
Chinese or Japanese stick ink is outstanding in its smoothness and intensity. You will need an ink stone on which to mix it. Some colours can be obtained in stick form: use a separate stone

for each so that the colours remain pure. Ink stones should be thoroughly cleaned after use.

Gouache
Designer's gouache is best for writing in colour. Available in a wide range of colours, this is an opaque medium that can be diluted with water. The label will indicate the colour's permanence (or fastness). A good initial selection of colours would be: Zinc or Titanium White, Jet Black, Cadmium Red, Alizarin Crimson, Winsor Blue, Cerulean Blue, Oxide of Chromium, Lemon Yellow, Cadmium Yellow, Burnt Sienna and Raw Umber.

Poster colour
Poster colour is not as smooth as gouache but is cheaper. It is particularly appropriate for larger work such as posters. It is sold in small jars, in a more limited range of colours than gouache.

Watercolour
Watercolour, with its translucent qualities, can be used to create interesting effects in calligraphic work. For example, drawing one letter over another will produce an "overprint" effect or touching a "wet" letter with another colour will make the colours run and fuse.

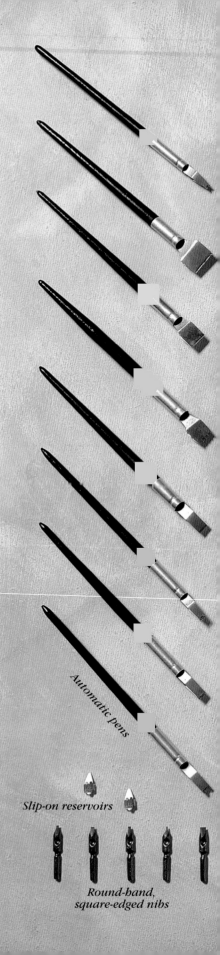

Automatic pens

Slip-on reservoirs

Round-hand, square-edged nibs

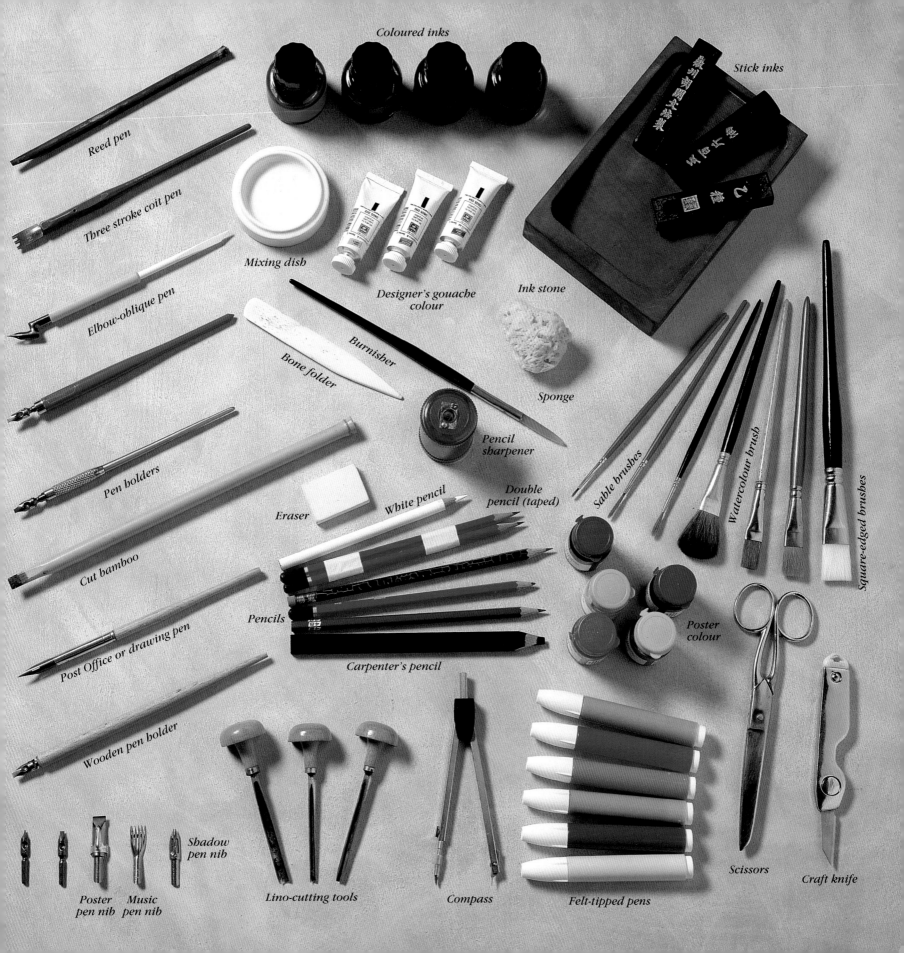

Coloured inks

Stick inks

Reed pen

Three stroke coit pen

Mixing dish

Designer's gouache colour

Ink stone

Elbow-oblique pen

Burnisher

Bone folder

Sponge

Pen holders

Pencil sharpener

Cut bamboo

Eraser

White pencil

Double pencil (taped)

Sable brushes

Watercolour brush

Square-edged brushes

Pencils

Poster colour

Post Office or drawing pen

Carpenter's pencil

Wooden pen holder

Scissors

Craft knife

Poster pen nib

Music pen nib

Shadow pen nib

Lino-cutting tools

Compass

Felt-tipped pens

Paper

There are three main categories of paper: hand-made, mould-made and machine-made. It has a range of finishes. Hot-pressed (HP) has the smoothest surface, "Not" (short for "Not hot-pressed" and known as "Cold Press" in the USA) has a matt surface and "Rough" has a matt, textured surface. Highly glazed or shiny papers are not suitable for calligraphy because the pen tends to skate over their surfaces.

For practice work, an A3 layout pad is a good choice: its paper has surprising bite and is sufficiently transparent for a time-saving sheet of guidelines to be placed underneath. Photocopying paper (A3) is also adequate and considerably cheaper if you buy it by the ream (500 sheets). Some wrapping paper can be an enjoyable and interesting alternative.

For finished work, calligraphers usually have favourite papers for different projects, and it is a good idea to build up a collection of different papers and get to know their properties. A certificate or menu would probably require a more robust paper than a quotation protected by framing. Paper with a watermark is best used with the correct reading side facing you, but either side of most papers may be used.

The "weight", or thickness, of the paper is measured internationally in grams per square metre (gsm). The United States tend to use lb measurements. Reasonable quality calligraphy paper for finished work will fall in a range between 150–350 gsm.

Work for reproduction needs a smooth-surfaced paper on which clean, crisp calligraphy is better produced.

Hand-made paper
This attractive paper is individually produced by dipping a mesh-covered frame, or mould, into a solution of fibres. Another frame, the deckle, holds the fibres in place – hence the attractive rough, or "deckle", edges.

Mould-made paper
Mould-made paper imitates hand-made paper, but is made in a machine using the same materials. It has two deckle edges on each sheet.

Machine-made paper
This paper is mass-produced and therefore the cheapest. It has grain direction: if you bend a sheet, it will be easier to fold with the grain than against it (just as tearing a newspaper with the grain is easier). However, this needs to be considered only if you are making a book, when the grain of the pages should always run in the same direction as the spine. Grain direction may also affect the application of a wash.

Coloured papers
Very satisfying effects can be achieved by using a light colour on a dark background. There is a good range of dark papers to choose from. Fabriano Roma is especially good and Canson is also suitable. A reasonable range of dark colours is available in each, Black paper is satisfying too and can be written on with good effect using automatic pens or brushes.

When you need to draw guidelines on dark paper, use a white pencil sharpened and roll-rubbed to a needle point. Draw the lines as lightly as possible, using little more than the pencil's own weight as pressure. They will then be easy to remove with an eraser.

Pergamenata

G.F Smith mould-made

T.H. Saunders cream wove

Pergamenata

Barcham Green

Fabriano Ingr

Canson

G.F. Smith
mould-made

Canson

Khadi papers

G.F. Smith
mould-made

Fabriano Roma

G.F. Smith
mould-made

Fabriano Roma

wrapping paper

Marlemarque

Parchemarque

Rives

Fabriano Roma

Simili Japon
cream wove

G.F. Smith
Strathmore Grandee

Archers

G.F. Smith
Strathmore Grandee

Rives

G.F. Smith
mould-made

Rives

G.F. Smith
mould-made

Cream and Sceptre

Elephantide

T.H. Saunders

Mohawk Superfine

Goatskin parchment

G.F. Smith
Strathmore Grandee

Goatskin parchment

Basic Terminology

A clear understanding of a few fundamental terms is necessary before learning how to create beautiful letterforms.

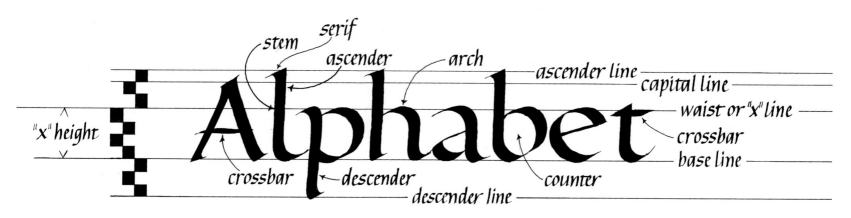

Letterforms

Letterforms dictate the "style" or "hand" in which you write and are made up of capitals and minuscule, or lower case, letters. The terms "upper case" and "lower case" derive from the days when printers kept a case of capital letters above that containing the small letters while they were typesetting. Text is usually in lower case because it is easier to read.

Above: Capital (majuscule) and lower case (minuscule) letterforms.

Above: The term "italic" generally indicates lettering that slants to the right. Informal italic writing and handwriting are usually "cursive": the letters are joined together. The joining strokes are known as "ligatures".

Letter height

The x height is the term used for the height of a lower case letter – such as the "x" – which has neither an "ascender" (the part of the letter that extends above the waist line) nor a "descender" (the part of the letter that extends below the base line). The x height is also useful in establishing the space between the written lines – or interline spacing – for which three x heights make a convenient starting point.

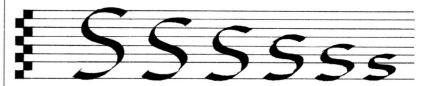

Above: This letter "s" has been drawn in varying x heights from 8 nib widths (forming a lightweight character) to 3 nib widths (creating a heavyweight character). Drawing this letter helps to establish the size of your writing. It would be possible to fit some letters between 2 nib widths, but "s" would create obvious difficulties.

Guidelines

Guidelines should be just strong enough to be seen and easily removed with a soft eraser. Use little more than the weight of the pencil to draw them. Use a sharpened and roll-rubbed white pencil on dark paper.

Weight

The relationship between the nib width and the x height determines the weight of a letter. An x height of 4 nib widths is normally used for the Round Foundational Hand (lower case): use this proportion to begin with.

Right: The same word has been written at 4¹/₂, 4, 3¹/₂ and 3 nib widths. The first sample is known as a "condensed" form and the latter two are "extended" forms.

Pen angle

Maintaining a constant angle between the square edge of the writing instrument and the horizontal writing line gives the characteristic thicker and thinner strokes of a letterform. The angle varies between one letterform and another.

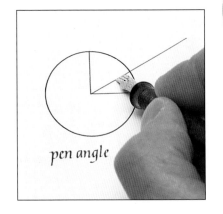

Right and above right: A pen angle of 30° is used to write the Round Foundational Hand.

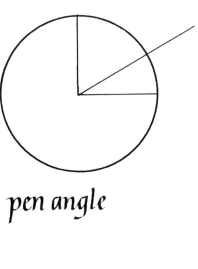

pen angle

Uniform height

Always draw the "waist" or x height guideline to indicate height. Bands of letters of uniform height are more visually satisfying, easier to read and play an important part in fundamental design.

Letters should be drawn between the guidelines to establish uniform height, but the round letters and the "points" of A, M, V and W should fractionally exceed these borders or they will look smaller, especially when they are next to flat-topped characters like E, T and Z.

ZOE ZOE

Above: The "O" (left) is the same height as adjacent letters but looks smaller. To counteract this optical illusion, rounded letterforms need to slightly exceed the guidelines (right).

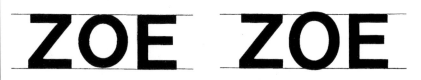

Above: Both capitals and lower case letters are more easily recognized by their tops. If only the bases of these letters had been illustrated it would not be possible to identify the words.

Proportion of capitals to lower case letters

Calligraphers normally establish the body height of their lettering by the number of pen widths it should contain. For the Round Foundational Hand, use 4 nib widths for the x height, a further 3 nib widths above for the ascenders and 3 nib widths below to contain the descenders. The capital letters should extend just 2 nib widths above the x height; they look ungainly if they are any higher.

Serifs

The embellishment at the beginning or end of the letter stem or curved stroke is known as a serif. In pen lettering this is normally a hairline, hook or triangular device. In Roman inscriptional lettering there was a natural tendency for the stone carver cutting his "V" with a mallet and chisel to produce these refinements when beginning or ending a letter. Serifs can be seen today in hundreds of derivative typefaces.

Numerals

Numerals are normally the same size as capital letters. These are known as "ranging numerals". Those that have ascenders and descenders, and relate more to the lower case, are described as "non-ranging". In the latter case, the 0, 1, and 2 equal the x height and the ascenders and descenders of the other numerals are shallower than the normal extensions of the lower case. There are variations to this rule, where "2" and "4" extend above the waist line.

Right: Ranging (above) and non-ranging numerals.

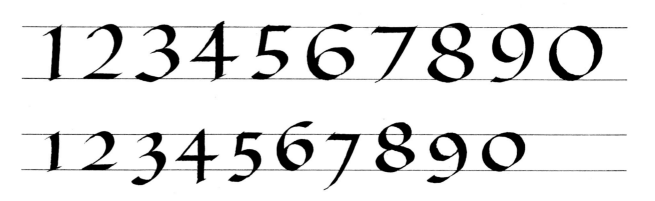

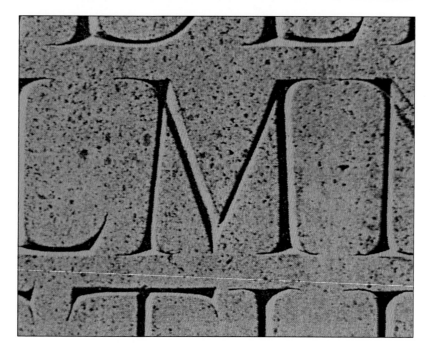

Left: Designing one's own greeting cards allows for many personal inclusions which would be unobtainable from a card store. This card is worked in gouache on vellum.

Above: A hand-drawn and painted "M".

Left: This Roman inscriptional "M" shows the typical curved serifs produced by the chisel of the letter carver.

THE LEFT-HANDED CALLIGRAPHER

Left-handers need to work hard to adopt various positions to accomplish calligraphic movements that are easier with the square-edged pen held in the right hand. The problem is partly solved by using a special "left oblique" nib. Experiment with different body and hand positions to find those most comfortable for you. Some left-handed people are able to flex their wrist into a hooked position, others write vertically or change the angle of the paper. It also helps to tilt the paper to achieve the letter stroke.

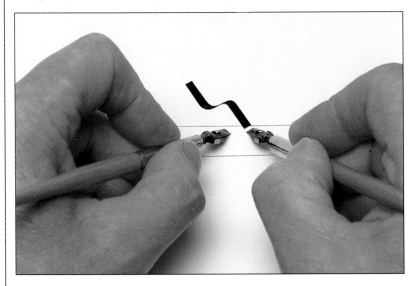

1 The left-handed writer has a problem making the strokes produced by the right-hander because of the angles involved.

2 A "left oblique" pen nib is a partial solution to the problem.

3 Using a left oblique nib and tilting the paper will allow you to imitate a right-handed calligraphic stroke.

Left: This beautiful piece of work uses stick ink on vellum.

The Collect for the Fourth Sunday after Trinity

Protector in te sperantium, Deus, sine quo
nihil est validum, nihil sanctum:
multiplica super nos misericordiam tuam,
ut, te rectore, te duce, sic transeamus per
bona temporalia, ut non amittamus aeterna.
Per Christum Dominum nostrum ✠
Amen

Preparing to Write

It is important to arrange your desk or table and chair so that you will be able to work comfortably. Adequate light is vital. Although daylight is best, an adjustable desk lamp will illuminate well, especially if you use a simulated daylight bulb. Choose a chair that is the right height and will support your back. Once you have found the writing position that suits you best, you can maintain it by moving the paper on the drawing board rather than shifting your general posture.

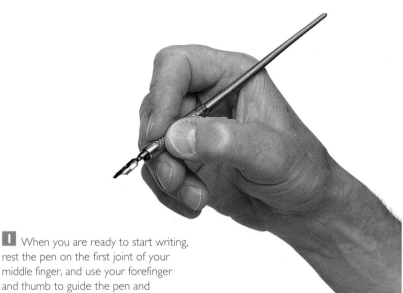

1 When you are ready to start writing, rest the pen on the first joint of your middle finger, and use your forefinger and thumb to guide the pen and maintain its angle.

2 A drawing board is essential and should be placed at a slope, so as to control the flow of ink from the pen. The degree of incline of the board is up to you, but it is important to feel comfortable. A T-square makes for easily drawn guidelines, as measurements need only be marked once.

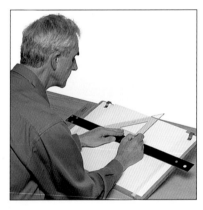

3 Use a set square with the T-square to establish any vertical guidelines you need for a piece of work.

4 Sit comfortably and hold the pen with a relaxed grip. One or two sheets of cartridge or blotting paper clipped or taped to the drawing board will provide a nice resilience. Tape a guard sheet to this to protect your work.

TIP

For small pieces of work, a plastic drawing plate (from office equipment suppliers) will hold the paper while the accompanying set square can be operated from ready-marked measurements.

MIXING THE INK

If you are using stick ink, you will need to prepare it for use by rubbing it down with distilled or purified water on an ink stone.

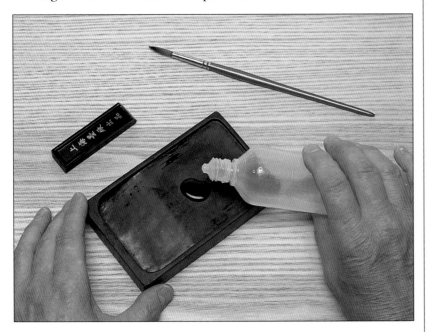

1 Pour a few drops of distilled water on to the ink stone.

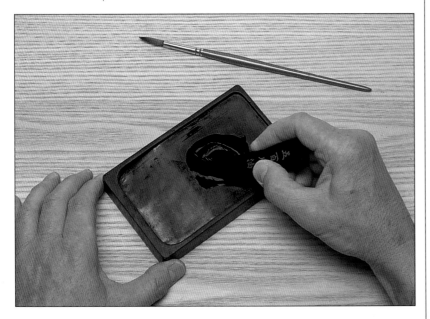

2 Rub the stick ink into the water and mix to a thin consistency that will flow easily. You will need to experiment to find the correct density, but for roughs, the ink can be much diluted.

MIXING COLOURS

It is important to mix sufficient colour to complete a piece of work. You will need to stir it from time to time while you are using it, adding a drop of water to maintain the right consistency. Cover the dish with clear film (plastic wrap) if you need to keep the colour from one session to the next. Some calligraphers add a drop of gum water or gum arabic to the gouache to increase its adherence to the paper and to make it easier to rub out any guidelines without smudging.

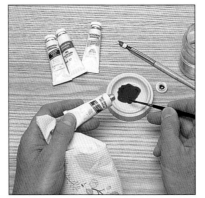

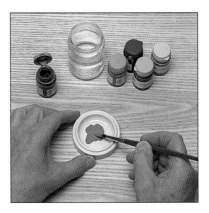

1 Mix designer's gouache on a palette or in a small dish. Dilute it to a consistency that will flow easily through the pen, using distilled water if possible, especially if the colour is to be kept between working sessions.

2 Dilute poster colour with distilled water in the same way as gouache.

3 When working on a dark background, light colours need to be sufficiently diluted to flow through the pen, but strong enough to remain opaque on the writing surface. Experiment with various colour mixes on the dark paper and wait until they are dry before making a decision. It's a good idea to keep samples of these colour mixes, with a note of what you used.

PREPARING THE PEN

Most ink stones contain a well to hold the rubbed-down ink, but calligraphers normally make the ink in smaller amounts as they go along and feed it into the pen with a brush.

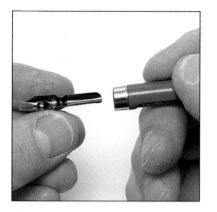

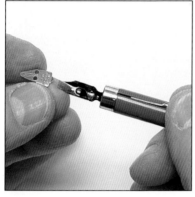

1 Place the pen nib in the pen holder – it must remain firm and not wobble.

2 If your pen does not have a built-in reservoir, place a slip-on reservoir on the front of the nib. It needs to stay firm but must not grip the nib tightly. The side wings of the reservoir may have to be bent slightly to achieve a good fit.

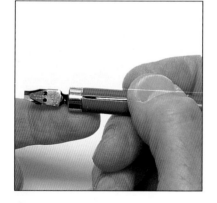

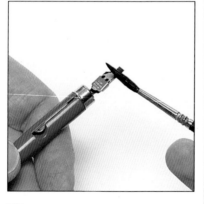

3 The rounded top edge of the slip-on reservoir should lie about 3mm/¹/₈in from the square edge of the nib.

4 Fill the pen using a brush, drawing it along the side of the nib to deposit the ink between the nib and the reservoir.

STRETCHING PAPER

Most calligraphy is done on paper that needs no preparation. However, if you want a watercolour background you must first stretch the paper, otherwise it will cockle, presenting a surface unsuitable for writing. Stretching the paper is also useful if you are planning a graduated wash, or any integrated watercolour work. The paper is not removed from the drawing board until the piece is completely finished.

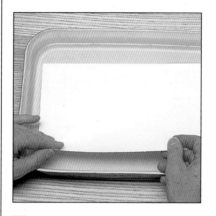

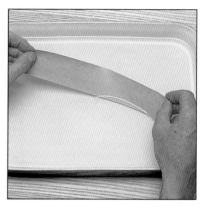

1 Cut a piece of paper a little larger than the planned size of your work, allowing a margin for the gummed paper tape to stick to the drawing board. Cut four lengths of tape a little longer than the sides of the paper. Immerse the paper in cold water for a minute or two. Drain the excess water by holding the paper by one corner.

2 Place the wet paper on the drawing board and moisten the first strip of gummed tape.

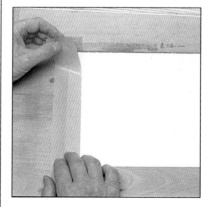

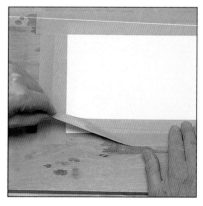

3 Lay down the gummed paper strip, overlapping both the paper and the board equally.

4 Lay the other gummed paper strips all around the paper and smooth down.

LAYING A WASH

Use a very dilute watercolour wash to produce a tinted background for calligraphy. Strong washes of colour are not suitable for pen work since the nib collects the pigment from the surface of the paper and will not then produce a sharp image. Applied on a tilted surface, the colour forms a pool at the bottom of each horizontal stroke which can be moved on with the next sweep of the brush.

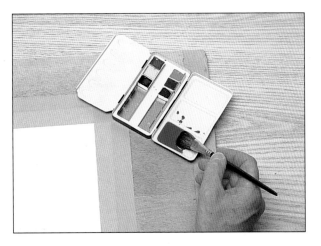

1 Mix more than enough watercolour to cover the paper.

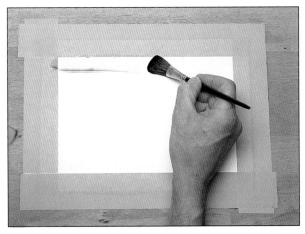

2 Tilt the drawing board and apply the wash in horizontal strokes, using a well-charged brush.

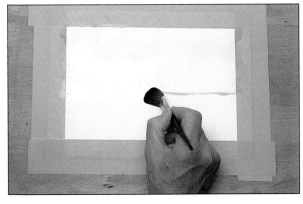

3 Work quickly, recharging the brush with each stroke as you collect the gravity-fed colour, and move down the paper.

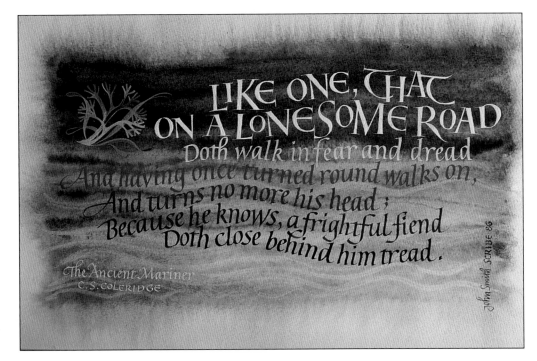

LIKE ONE, THAT ON A LONESOME ROAD
Doth walk in fear and dread
And having once turned round walks on,
And turns no more his head;
Because he knows, a frightful fiend
Doth close behind him tread.

The Ancient Mariner
C.S.COLERIDGE

John Smith SCRIBE 86

Above: A watercolour wash was applied to hand-made paper before the lettering was added. Versals and pen lettering use designer's gouache.

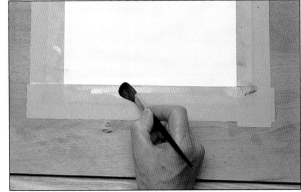

4 When you reach the bottom of the paper, absorb the excess watercolour with the empty brush.

Mark-making with a Square Edge

Calligraphy's characteristic thick and thin strokes and subtle gradations from one to another are created by maintaining a square-edged writing instrument at a constant angle. For the Round Foundational Hand, this angle should be approximately 30° (the two o'clock angle). Try mark-making – and some patterns – using your chosen pen. To begin with, use ink that has been much diluted so that the pen flows freely. The examples on this page show the effects that can be achieved using a variety of pens and other writing instruments.

1 A carpenter's pencil, has a large flat lead that can be sharpened to a square edge using a knife.

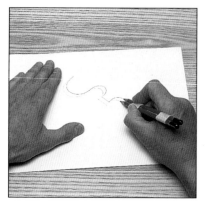

2 To improvise a square-edged writing instrument, make a double pencil by taping two ordinary pencils securely together and lining up their tips precisely.

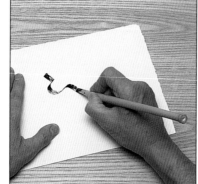

3 Writing with a bamboo pen.

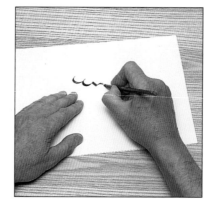

4 Using a reed pen.

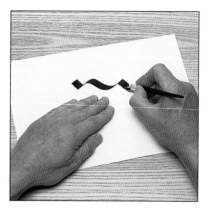

5 Automatic pens are used for writing larger letters. Their construction – of two bent, flat metal pieces – provides a built-in reservoir.

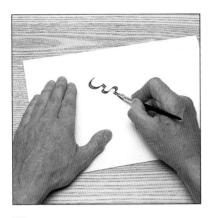

6 Some automatic pens have divided writing edges that produce a double stroke or shadow effect.

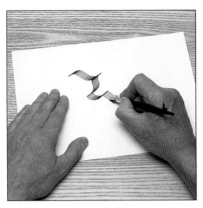

7 The automatic music pen is so-called because it imitates the five lines on music manuscript paper.

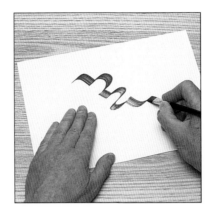

8 Using a square-edged brush and using fairly dry colour will achieve an interesting 3D effect.

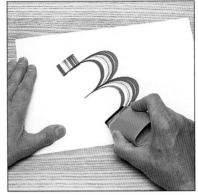

9 A wide felt-tipped pen is good for larger work.

10 Three-pronged felt pen.

11 A steel pen produces clean, sharp work

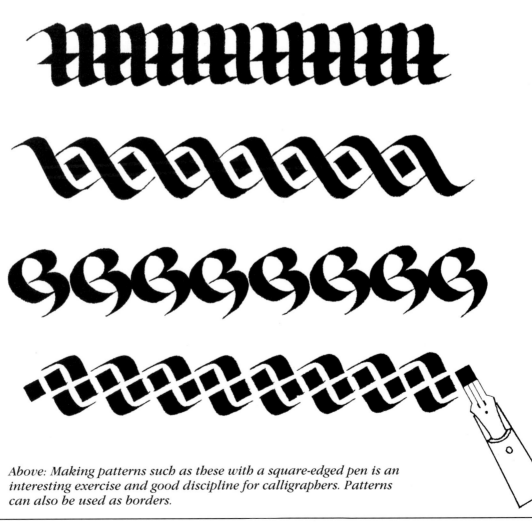

Above: Making patterns such as these with a square-edged pen is an interesting exercise and good discipline for calligraphers. Patterns can also be used as borders.

Lettering with an Automatic Pen

Automatic pens are especially useful for posters and large-scale display work, but they can also be used for headings (headlines), when contrasts in letter size will have considerable impact. Double stroke, shadow and "music" pens are also available in this range, and they can be purchased from most suppliers of calligraphic materials.

Left: A large automatic pen with watercolour is used for this simple message on watercolour paper.

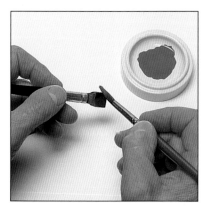

1 Feed the automatic pen from the side using a brush.

2 Try the pen on spare paper to make sure the ink is flowing freely before venturing to use it on your work: the music pen can be especially difficult.

3 When you are satisfied the ink is flowing correctly, write your letters in the usual way.

4 Form the letters as you would with any square-edged writing instrument, keeping the pen angle constant.

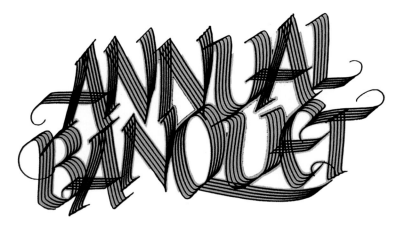

Left: Automatic pens on cartridge paper are useful for larger scale poster work.

Above: An automatic "music" pen with stick ink gives a striking effect on this menu card.

Lettering with a Square-edged Brush

The square-edged brush is not as easy to use as a pen because, while a steel nib will tolerate a marginal amount of "pushing", the brush, apart from some quirky fine strokes with its corner, insists on making marks by being "pulled". But with practice the brush is a delightful writing tool and will produce splendidly effective lettering.

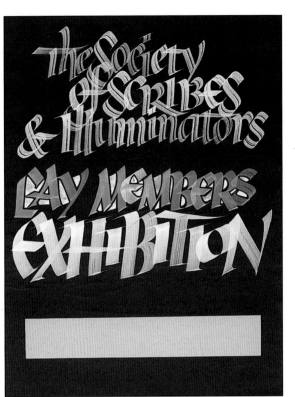

Left: Poster using square-edged brushes. White poster colour on black sugar paper.

1 Dilute some designer's gouache or poster colour with water in a dish.

2 Use the square-edged brush with normal calligraphic movements. Using it with less colour will produce attractive hairlines within the strokes.

3 Make a slight change of angle at the end of the stroke and lift the edge of the brush so that its corner creates a serif.

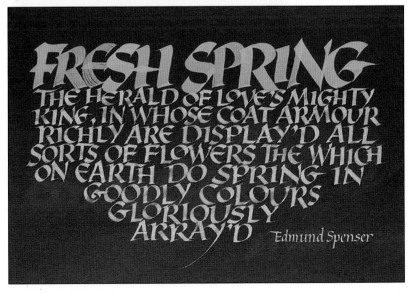

Above: This attractive piece of work uses coloured gouache made with square-edged brushes on dark sugar paper.

The Skeleton Alphabet

Understandably, newcomers to the craft of lettering are attracted to more decorative alphabets than this one. But you should take more than a glance at what is known as the skeleton alphabet, for it is on this simple geometrical structure that all the other alphabets are based.

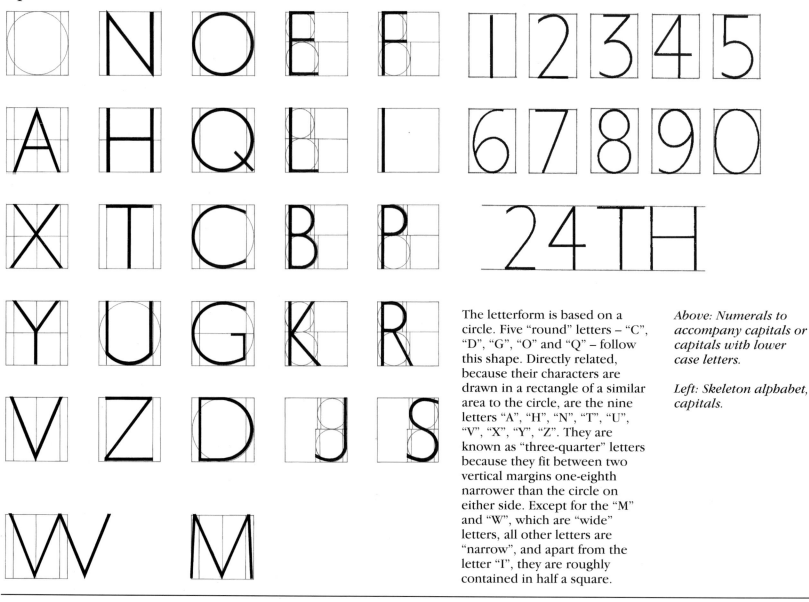

The letterform is based on a circle. Five "round" letters – "C", "D", "G", "O" and "Q" – follow this shape. Directly related, because their characters are drawn in a rectangle of a similar area to the circle, are the nine letters "A", "H", "N", "T", "U", "V", "X", "Y", "Z". They are known as "three-quarter" letters because they fit between two vertical margins one-eighth narrower than the circle on either side. Except for the "M" and "W", which are "wide" letters, all other letters are "narrow", and apart from the letter "I", they are roughly contained in half a square.

Above: Numerals to accompany capitals or capitals with lower case letters.

Left: Skeleton alphabet, capitals.

Right: Skeleton alphabet, lower case.

o a u o a i u

k s h b o f j

Since numerals will not easily relate to a geometrical pattern, these have been drawn within the "three-quarter" rectangle to indicate a concept of their form and proportion. Numerals placed with a capital letter are drawn the same height. Numerals, which accompany lower case letters more readily, match the text if even numbers are a little higher than the x height, and odd numbers (except 1) correspondingly extend below the base line, though you may sometimes see alternatives to this rule.

x y y d e l t

v z n p q t t

w m g g n

1 2 3 4 5 6 7 8 9 0

1st 2nd 3rd

Right: Numerals that can be used with lower case letters.

25

Roman Lettering

The Romans' appreciation and development of letterform culminated in what we now regard as the most famous piece of inscriptional lettering. This lettering is seen in Rome at the base of a column erected to the Emperor Trajan in AD 114. These beautifully conceived and executed Roman capitals have exerted their influence on hand lettering, calligraphy and numerous typefaces ever since. Made up of simple geometric forms, thick and thin strokes and graduating curves, the inscription shows the obvious influence of the "square edge" and was probably first painted with a flat brush or reed before being incised with a mallet and chisel.

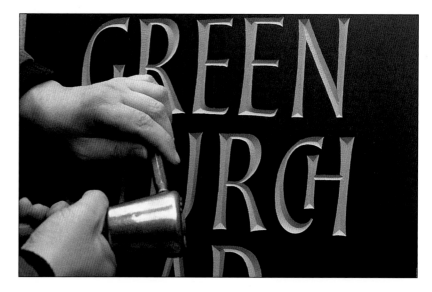

Above: The craftsman John Shaw at work with mallet and chisel, carving out beautiful letterforms.

Below: Detail of the Trajan Column inscription (AD 114). It boasts an austere quality in its letterforms.

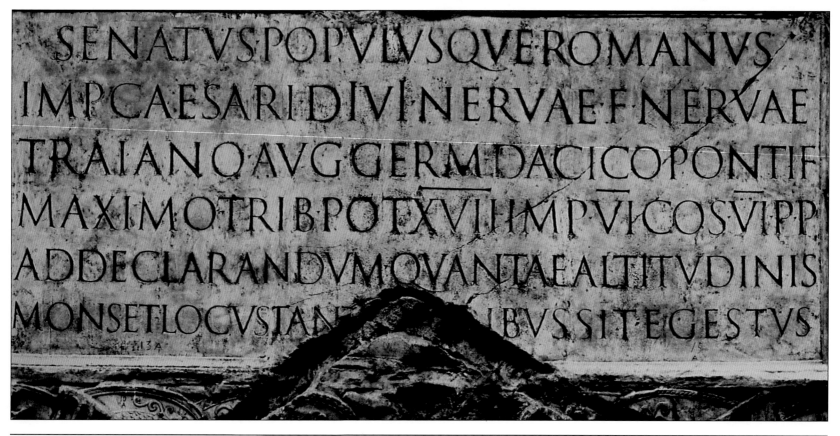

For initials or headings, carefully draw the Roman letter and paint with a fine-pointed sable brush.

Above: A piece of Welsh slate with elegantly incised and gilded lettering

Above: This impressive plaque has been carved out of Welsh slate. The coat of arms is carved in relief, painted and gilded.

Right: Beautifully drawn Roman capitals.

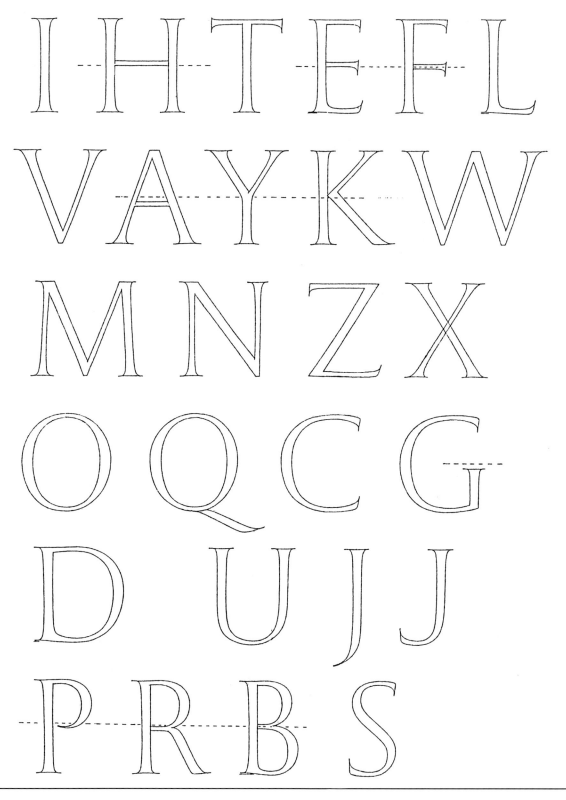

Round Foundational Hand

The Round Foundational Hand was developed by Edward Johnston, who based his research on a tenth-century manuscript in the British Library. The alphabet illustrated is a modernized version. The script is called "round hand" because the underlying shape is the circular "o". It is ideal for the beginner, who should use an x height of 4 nib widths. Extend the ascenders and descenders an additional 3 nib widths above and below the x height. A pen angle of 30° will give vertical strokes slightly thicker than the horizontal strokes. If the angle is too steep, the results will be heavy "arches" and "feet" and verticals that are too thin. But some letters are improved by slight variations in the angle: the thick strokes of "v", "w", "x", and "y", for example, require an angle of nearly 45° and a flatter angle will produce a thicker diagonal in the second stroke of "z".

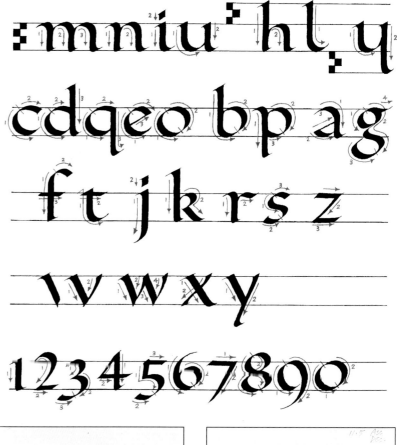

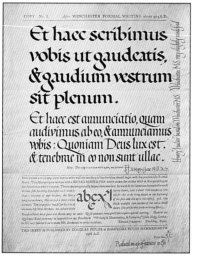

Above: A writing sheet of Edward Johnston's (1872–1944): he developed the Round Foundational Hand.

1 Maintain the 30° angle as you draw the pen vertically towards you.

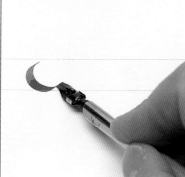

2 For the round forms such as "c", "d", "q", "e", begin with a generous arc moving in an anticlockwise (counterclockwise) direction.

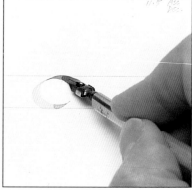

3 Link with the beginning of the first stroke, draw a short clockwise arc, and finish the stroke, maintaining the 30° angle at this point.

Left: Round Foundational Hand, alphabet and numerals.

Right: As an alternative to the triangular form, the serif can be made with a small clockwise circular movement that straightens out into the vertical stroke in a single movement.

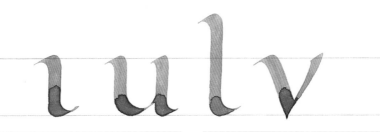

TIP

Draw faint guidelines for the ascenders and descenders to begin with. In time, you should be able to guess the lengths of these extensions and use only the x height lines as a guide.

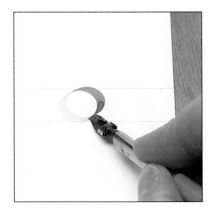

4 Pick up the first round stroke's hairline and complete the "o" shape with a generous clockwise movement.

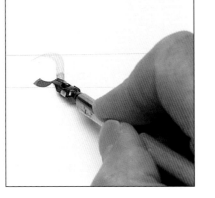

5 Make the second stroke of "a" with an abrupt anticlockwise (counter-clockwise) arc, finishing with a hairline.

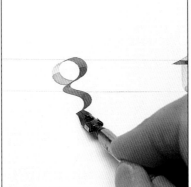

6 For the second stroke of "g", sustain the pen angle with a graceful curve that begins with a clockwise curve, swings into an anticlockwise arc and reverts to a clockwise arc.

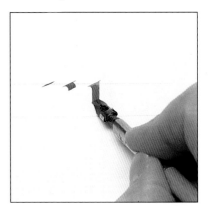

7 Form the triangular serif with three smaller movements.

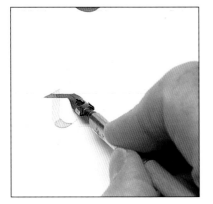

8 Draw the cross bar of "f" and "t" so that it sits immediately under the x height line. Make sure the pen angle does not steepen beyond 30°.

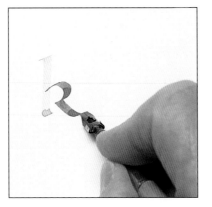

9 Begin the second stroke of the letter "k" with a clockwise movement and finish with a flourish.

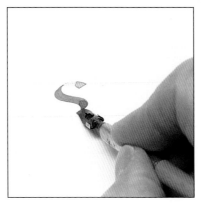

10 Produce the letter "s" with a snake-like movement, beginning and ending with a hairline. This can be the first or second stroke of the letter.

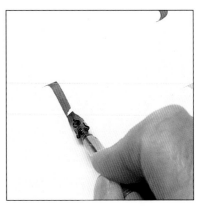

11 Make the points at the bases of the letters "v" and "w" by lifting the right-hand side of the pen nib as it approaches the base line and dragging the residue of ink in the same direction with its corner.

Continued ⇒

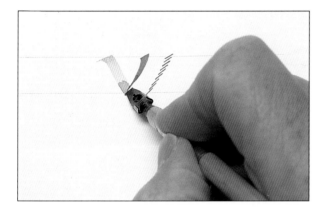 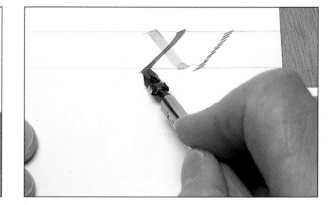

12 Begin the second stroke of the "v" at the usual 30° angle, but make the angle steeper as you sweep down to join the pointed base.

13 Draw the pen straight down into the descender for "y".

14 To complete "x", start with a 30° pen angle, make the angle steeper as you make the diagonal stroke, and finish with a 30° angle.

Left: A beautiful example of the Round Foundational Hand.

Opposite: This Communion Service uses goose quills in Chinese ink, blue and vermillion watercolour with the addition of raised and burnished gold, on unstretched vellum.

SO GOD LOVED THE WORLD THAT HE GAVE HIS ONLY BE-GOTTEN SON

to the end that all that believe in him should not perish, but have everlasting LIFE

COME UNTO ME ALL THAT TRAVAIL AND ARE HEAVY LADEN, AND I WILL REFRESH YOU

TAKE, EAT, THIS IS MY BODY WCH IS GIVEN FOR YOU DO THIS IN REMEMBRANCE OF ME

DRINK YE ALL OF THIS FOR THIS IS MY BLOOD OF THE NEW TESTAMENT WHICH IS SHED FOR YOU AND FOR MANY FOR THE REMISSION OF SINS; DO THIS AS OFT AS YE SHALL DRINK IT IN REMEMBRANCE OF ME

[The page reproduces, in dense calligraphic lettering arranged in columns, the text of the Order of the Administration of the Lord's Supper or Holy Communion from the Book of Common Prayer, including the Lord's Prayer ("Our Father which art in heaven…"), the Nicene Creed ("I believe in one God the Father Almighty…"), and the several Collects, Prayers, and the Gloria ("Glory be to God on high…"). An ornamental metal cross with a circular rose motif appears at the centre of the page.]

Complementary Capitals with a Square-edged Pen

Many of the pen movements used to write the Round Foundational Hand are also used for the complementary capitals. Remember to use the same 30° pen angle, so, like the carved Roman inscriptional lettering from which these capitals derive, the cross bars of the "E", "F", "H" and "T" will be thinner than the down-strokes.

Draw the capitals to a height of 6 pen widths. The forms of the "C", "O", "S", "U", "V", "W", "X" and "Z" are similar to the lower case. To make the diagonal strokes of the letters "A", "M", "N", "V", "W", "X" and "Y", adjust the pen angle to about 45°. The comparatively thin uprights of the letters "M" and "N" need a steeper pen angle of around 60°. The second and third strokes of both the "E" and "F" have modest serifs made by exerting slight pressure at the end of the stroke: this will produce a little extra ink that you can drag down using the corner of the nib.

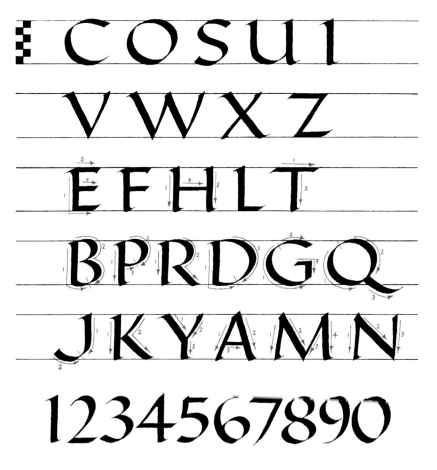

Above: Complementary capital letters, drawn with a square-edged pen, to accompany the Round Foundational Hand.

1 Keep the nib at a constant 30° angle as you move into and out of the vertical stroke.

2 Make sure the cross bar links well to the previous stroke and that the pen does not steepen beyond the 30° angle.

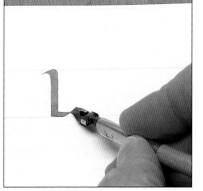

3 For "E", "B" and "D", continue the downward stroke with an anticlockwise (counterclockwise) movement. There is no need to lift the pen.

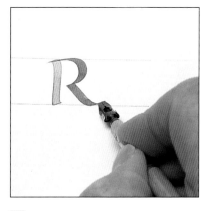

4 For the second stroke of "R", make a clockwise movement and, without lifting the pen, finish with a flourish.

Far right: A birthday greeting executed in designer's gouache on Whatman's H.P. paper.

Right: A design using Chinese stick ink, raised and burnished matt gold, watercolour and gouache on vellum.

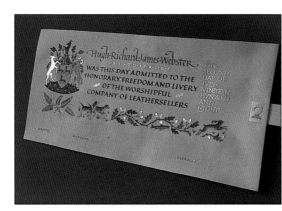

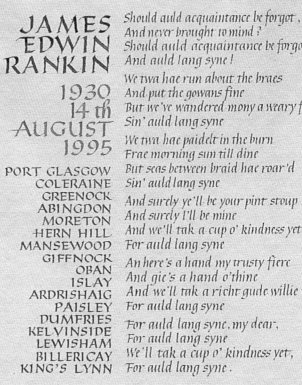

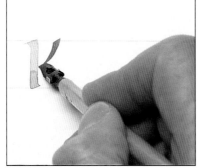

5 For the final stroke of "G", make the horizontal and vertical movements without lifting the pen. End with the pen at the same angle as the previous stroke.

6 For "K", make a curved diagonal movement, ending with a fine line and preparing for a final flourish.

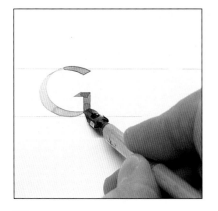

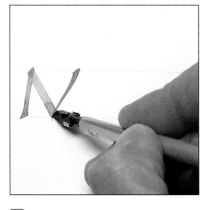

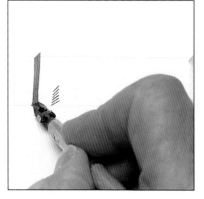

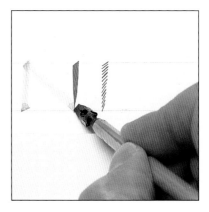

7 Produce the diagonal stems of "A" and "M" by starting at a steep angle. Flatten the angle as you approach the base line and flick the pen to the right to form a serif.

8 Make this marginally curved diagonal movement, used for "M", "V" and "W" by reducing its width with a subtle steepening of the pen and finishing with the same angle as the previous stroke.

9 Produce the thin vertical stem that begins "M" and "N" by steepening the pen angle. Finish by flattening it to create a serif.

10 The final stroke of "N" begins with a 30° pen angle and gradually steepens as you approach the base line and the point of the previous stroke.

The Italic Hand

The name of this style gives a clue to its identity, for it was developed during the Italian Renaissance to give a swift, elegant and rhythmic pen letter. It is characterized by its lightness of weight, its forward slope, springing arches and compressed form based on an elliptical "o". The less formal style, especially when written with a small pen, can be cursive and relates closely to italic handwriting. Italic lends itself happily to flourishing and the capitals to swash letters. Use 5 pen widths for an Italic x height. Add an additional 4 pen widths for extravagant ascenders and descenders and use 7 pen widths for the capitals. You should hold the pen at an angle of between 30° and 45° to the writing line. The forward slope of the letters should be consistent, at any angle between 5° and 12°. The alphabet illustrated has been drawn at a 5° angle.

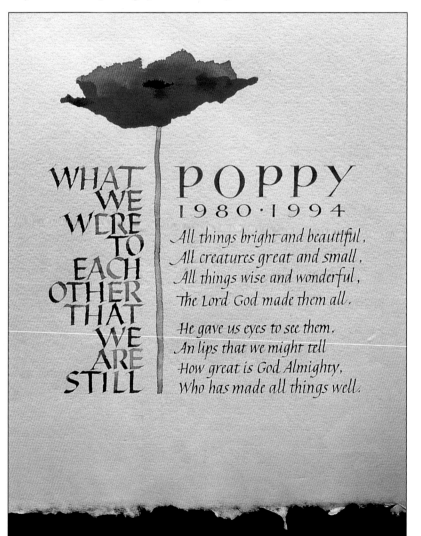

Above: The style in which this word has been written indicates the "rhythm" and "spacing" you should try to achieve in the Italic Hand.

WHAT WE WERE TO EACH OTHER THAT WE ARE STILL

POPPY
1980 · 1994

All things bright and beautiful,
All creatures great and small,
All things wise and wonderful,
The Lord God made them all.

He gave us eyes to see them,
An lips that we might tell
How great is God Almighty,
Who has made all things well.

Above: Note the complementary poppy fringe and deckle edge of this hand-made paper. This memorial piece to a pet dog is executed in watercolour and designer's gouache on hand-made paper.

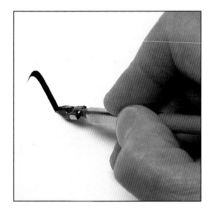

1 Hold the pen at a constant angle and draw the letter stem towards you, maintaining a slant of about 5°.

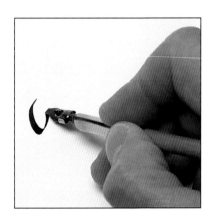

2 Draw the elliptical bowls of letters such as "a" with a curved anticlockwise (counterclockwise) pen stroke and a light upward movement towards the beginning of the next stroke.

abcdefghijklmn

opqrstuvwxyz

Above: The Italic Hand, lower case. The colours indicate the order in which the strokes should be made: red for the first stroke, blue for the second, green for the third and purple for the fourth.

TIP

Lower case Italic letters have fewer pen lifts than the Round Foundational Hand. The letter "m", for example, can be written without lifting the pen at all, but to achieve this you must put very little pressure on the pen on its upward movement.

3 Complete the letter "o" with an elliptical clockwise curve linking the hairlines at start and finish.

4 Form the cross bar of "t" by exactly linking the pen angle with the beginning of the preceding stroke and using a slightly flourished horizontal movement.

5 Complete letters such as "g", "j"and "s" with a movement that pulls the pen to the right and finishes with a hairline link to the previous stroke.

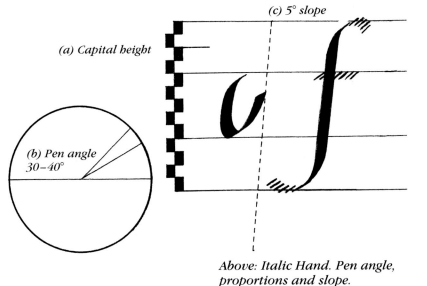

(c) 5° slope

(a) Capital height

(b) Pen angle 30–40°

Above: Italic Hand. Pen angle, proportions and slope.

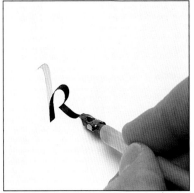

6 Produce "k" in one graceful movement, using a well-charged pen: the upward stroke has to glide very lightly over the writing surface.

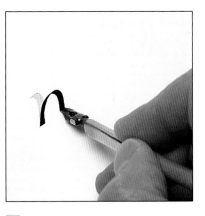

7 Make this characteristic shape by lightly pushing the pen upwards and outwards, forming an elliptical arch prior to another downward movement.

Continued ⇒

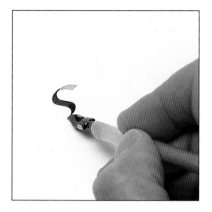

8 Produce this satisfying "s" stroke with a snake-like movement that begins and ends with a hairline. Form the "s" with a slightly steeper pen angle if your normal angle is less than 45°.

9 Draw the "u" echoing the "springing arch" of the letter "n", remembering not to exert any pressure on the upward pushing stroke.

10 End the diagonal stems of "v" and "w" with a point, formed by lifting the right side of the nib. Judge the slant of the stem carefully: an imaginary line at 5° to the vertical would bisect the angle made by this and the succeeding stroke.

11 Draw this thin diagonal with a steepening shift of the pen to finish in the thinnest line your pen can form, to link with the point of the preceding thicker stroke.

ABCDEFGHIJ
KLMNOPQR
STUVWXYZ
1234567890

Right: Italic capitals can be used in formal or informal work, on their own or contrasting with the lower case. Use the same pen movements for these capitals as for those associated with the Round Foundational Hand.

Right: Numerals to accompany the Italic Hand.

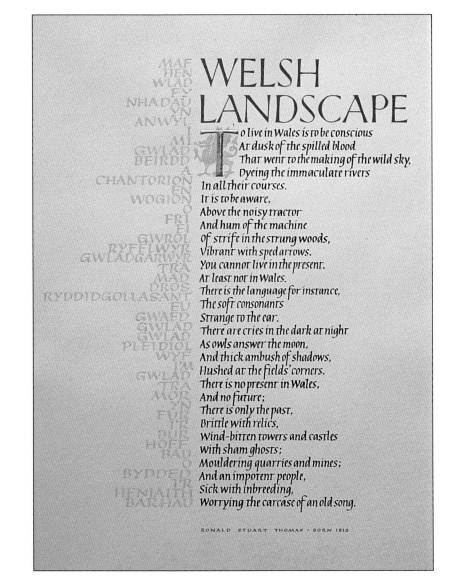

WELSH LANDSCAPE

To live in Wales is to be conscious
At dusk of the spilled blood
That went to the making of the wild sky,
Dyeing the immaculate rivers
In all their courses.
It is to be aware,
Above the noisy tractor
And hum of the machine
Of strife in the strung woods,
Vibrant with sped arrows.
You cannot live in the present.
At least not in Wales.
There is the language for instance,
The soft consonants
Strange to the ear.
There are cries in the dark at night
As owls answer the moon,
And thick ambush of shadows,
Hushed at the fields' corners.
There is no present in Wales,
And no future;
There is only the past,
Brittle with relics,
Wind-bitten towers and castles
With sham ghosts;
Mouldering quarries and mines;
And an impotent people,
Sick with inbreeding,
Worrying the carcase of an old song.

RONALD STUART THOMAS · BORN 1913

When, in disgrace with fortune and men's eyes,
I all alone beweep my outcast state,
And trouble deaf heaven with my bootless cries,
And look upon myself, and curse my fate,
Wishing me like to one more rich in hope,
Featured like him, like him with friends possest,
Desiring this man's art and that man's scope,
With what I most enjoy contented least;
Yet in these thoughts myself almost despising,
Haply I think on thee,—and then my state,
Like to the lark at break of day arising
From sullen earth, sings hymns at heaven's gate;
For thy sweet love remember'd such wealth brings
That then I scorn to change my state with kings.

WILLIAM SHAKESPEARE · SONNET XXIX

Joan Pilsbury
Scribe 1996

Above: These Italics in stick ink, designer's gouache and raised gold initial on mould-made paper have a natural rhythm.

Right: An elegant example of the Italic Hand with a burnished gold initial, stick ink and colour on vellum.

Swash Letters and Flourishing

Swash letters are ornamental Italic capitals with an exuberant flourish. They should express freedom and spontaneity but should not detract from the shape of the letter. Flourishing needs to be done with confidence and liveliness, but practising it is enjoyable and satisfying. Ascenders and descenders lend themselves well to flourishing, and the technique can often be used to fill spaces at the end of lines. Swash letters are particularly effective on initial letters, and are very suitable for monograms and logos, but if several are combined the spacing can become ungainly, so they need to be used with restraint. Use a similar pen angle and x height proportion to those used for the Italic Hand.

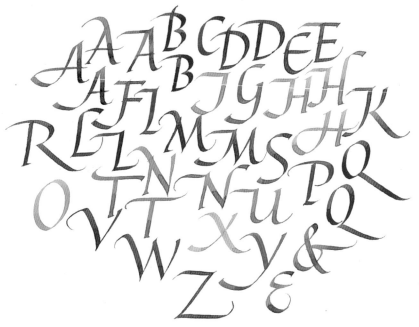

Above: Coloured decorative alphabet with some alternative flourishes.

Right: Experiment with flourishes on single words.

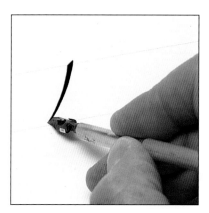

1 Draw the thin diagonal stems of letters such as "A" with a downward sweeping movement and a gradual steepening of the pen angle from its 30° starting position.

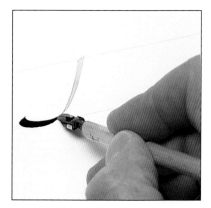

2 Add this flourish by resuming the original pen angle and linking up to the thin ending of the diagonal stroke.

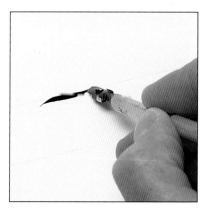

3 To produce this opening flourish, use a subtle wave movement. Try to begin and end the stroke with a hairline, and do not accentuate the wave.

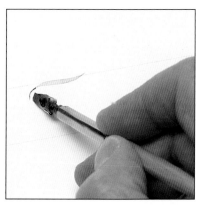

4 You can enhance the flourish further by extending the initial hairline with the corner of the nib. This is easier to do while the initial stroke is still wet.

5 Form the elliptical curves by maintaining a constant pen angle, and try to produce very thin joins.

6 Finish "R" and "K" with a flourishing pen movement, ending in a hairline. It can sometimes finish below the base line.

Above: Here, flourishes are executed to balance the design.

Left: The alphabet in Swash capitals.

A B C D E F G H
I J K L M N O P Q
R S T U V W X Y Z

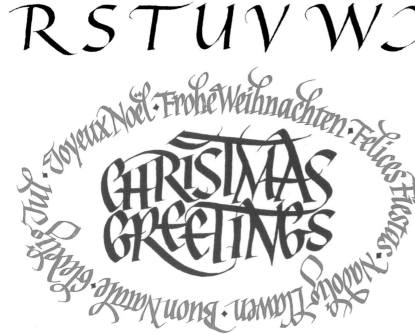

Left: In this colourful Christmas card, lower case flourishes and Swash capitals are effectively combined.

Right: Hand-carved and painted in Welsh slate.

Below: Numerals to accompany Swash capitals.

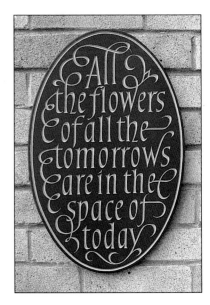

1 2 3 4 5 6 7 8 9 0

Gothicized Italic

There are many variations of this style of lettering, which is sometimes referred to as "Pointed Italic". It combines the qualities of Italic with some of the attraction of Gothic or "Black Letter" alphabets to produce crisp, lively letter shapes. As with Gothic lettering, close letter spacing produces an intense and vigorous texture and a highly decorative page. You will find it easier to master once you have gained some confidence in the Round Foundational and Italic Hands.

The pen angle of 30° is the same as for the Round Foundational Hand, but subtle twists of the pen can produce contrasting hairlines and sharp serifs. The x height, at 5 nib widths, as well as the ascenders and descenders extending an additional 4 and the capitals at 7 nib widths, uses the same proportions as the Italic Hand. This style of lettering can be varied to produce different effects.

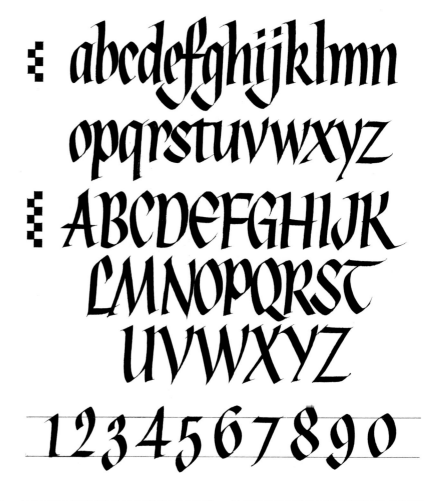

1 Hold the pen at a 30° angle, to make an elliptical anticlockwise (counterclockwise) stroke. Finish with an upward movement to leave a hairline when the pen floats off the surface.

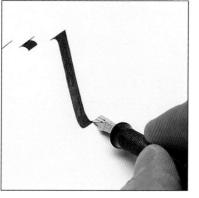

2 Form the serif with two separate pen strokes and a third stroke to join them, continuing downwards into the vertical stroke and ending with a sharp angular movement.

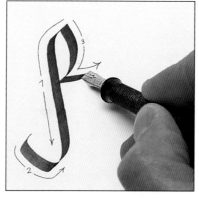

3 Slightly lift your pen nib at the end of each stroke of the letter "f", to produce a hairline with the corner of the nib.

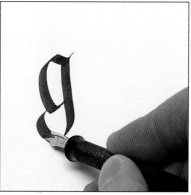

4 Complete the flourish of the "g" with an anticlockwise movement to link up with the end of the previous pen stroke.

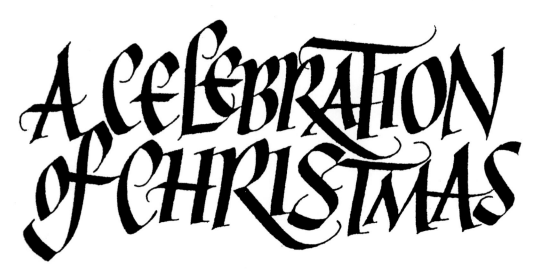

Opposite: Gothic Italic Script in lower case, capitals and accompanying numerals.

TIP

Numerals should emulate the fundamental shapes of the letters. They may be non-ranging, as illustrated, or ranging. The number 8 is drawn as two separate "o"s.

5 Push the pen upwards from the wet stem of "n" or "m" to create a pointed arch.

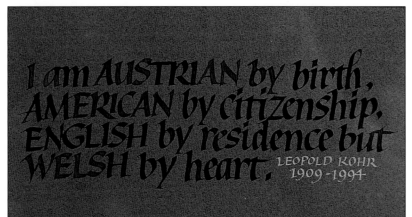

Above: Flourished Gothicized italic capitals are very good at space filling.

Left: Quotation from Leopold Kohr. A combination of upper case and lower case Gothic Italics looks effective in watercolour on mould-made paper.

6 Draw the letter "s" with a steeper pen angle.

7 Gradually lift your pen on the diagonal stems of "v", "w" and "y" to finish with a point made with the corner of the nib.

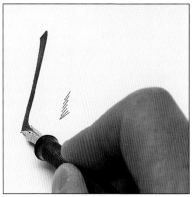

8 At the end of this diagonal stroke, make a quick turn with the pen to form the base serif of such letters as the capital "A" and lower case "y".

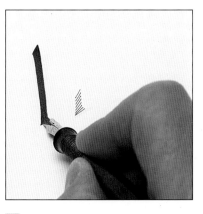

9 To make the first stroke of the capital "N", angle the nib at 45° (or steeper) and, as you approach the base line, make a swift change in the pen angle to form a small serif.

Uncials

Uncial writing was the standard book hand of scribes from the fifth century to the eighth and is found in the oldest surviving copies of the Bible. The Uncial preceded the development of minuscule letters, and a hint of ascenders and descenders can be seen in some of the letter forms. Uncials should be drawn to an x height of 3 (or 3¹/₂) nib widths. As in the alphabet illustrated, they are frequently drawn with the pen parallel to the writing line, though cross bars and some letters require an obvious shift in pen angle. The flat tops of the letters give a pleasing emphasis to the band-like quality of the script running across the page. There is a wide variety of alphabets to copy and alternative constructions for many of the letterforms.

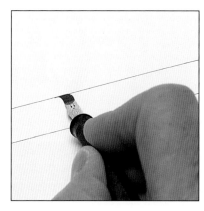

1 To form the flat serif, hold the pen parallel to the writing line and make a small clockwise curve.

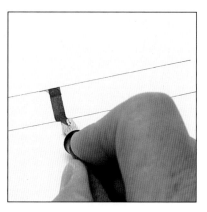

2 With the pen resting on the guideline, make a vertical downward stroke to link up with the first serif mark, finishing at the base line with a slight movement to the right.

JANUARY COLD DESOLATE
FEBRUARY ALL DRIPPING WET
MARCH WIND RANGES
APRIL CHANGES
BIRDS SING IN TUNE
TO FLOWERS OF MAY
AND SUNNY JUNE
BRINGS LONGEST DAY
IN SCORCHED JULY
THE STORM-CLOUDS FLY
LIGHTNING-TORN
AUGUST BEARS CORN
SEPTEMBER FRUIT
IN ROUGH OCTOBER
EARTH MUST DISROBE HER
STARS FALL AND SHOOT
IN KEEN NOVEMBER
AND NIGHT IS LONG
AND COLD IS STRONG
IN BLEAK DECEMBER

CHRISTINA ROSSETTI

Above: This Christina Rossetti poem is written in Uncials with gouache on hand-made paper.

3 When forming "A", "V" and "Y", place the pen nib on the guideline and, keeping the pen angle parallel to the line, make a diagonal downward stroke.

4 With the pen angle parallel to the writing line, push the pen up through the completed stem (without exerting any pressure – the wet ink remaining on the previous stroke will help). Finish the bowl shape with a clockwise movement and complete "B", "K" and "R" without a pen lift.

5 For the round forms, hold the pen at an angle of about 10° to the writing line and make an anticlockwise (counter-clockwise) stroke, finishing off with a hairline.

✠ ABCDEFGhIJKLMN
OPQRSTUVWXYZ

6 Make "C","G" and "E" with the pen held at a 10° angle. Pick up the top hairline and make a short, curved clockwise stroke, lifting the right side of the nib to create a subtle serif on completion. To complete "O", hold the pen at the same 10° angle and make a clockwise movement from the hairline at the top of the previous stroke to the one at the base line.

Top: The alphabet in Uncials.

Above: Psalterium Romanum cum Canticis (detail). Eighth-century manuscript written in Roman Uncials.

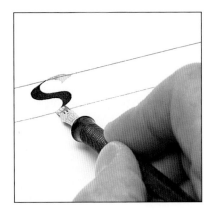

7 For the second stroke of the"S", hold the pen at a slightly steeper angle (20–30°) on the hairline and draw a snake-like anticlockwise (counter-clockwise), then clockwise, stroke to finish with a hairline at the base.

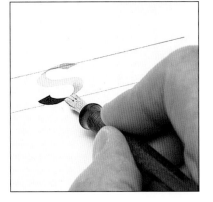

8 Resume a pen angle of around 10° to the writing line to complete the letter, and draw a fairly flat anticlockwise curve to link up with the previous stroke.

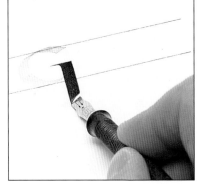

9 Complete "G" using the same movement as for the vertical stems of "F", "P", "Q" and "Y". Finish the down-stroke by lifting the right side of the nib to produce a "trailing-off" shape.

TIP

Although the normal square-edged pen can be held at this angle without too much difficulty, right-oblique nibs can be bought, which the right-hander can use more comfortably.

Versals

Versals are capital letters, used in early manuscripts to mark verses, paragraphs and chapters. Frequently drawn in the margin, they added adornment and colour that greatly enriched both page and book. Deriving from Roman capitals, they are characterized by a stronger contrast between thick and thin strokes. Their vertical stems tend to be top-heavy, and their serifs, unlike Roman serifs that mould into the stem, are thin hairline strokes.

Versals are usually drawn with a pen about one-third the width of the vertical stem, which in turn determines the thickness of the cross bar. They may also be drawn with a pointed brush or with a fine pen and "filled in". The fine serifs are made at right angles to the main strokes.

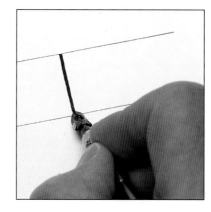

1 Draw a downward stroke with the pen angle at 90° to its direction.

2 Draw the vertical stem with two slightly inward curving strokes, keeping the pen angle at 90° to its direction. The hairline serifs are made horizontally using the same pen angle. Make the stem slightly top-heavy.

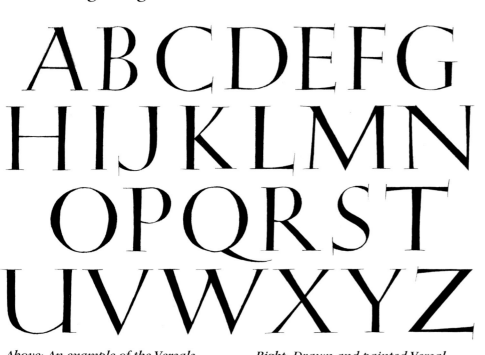

ABCDEFG
HIJKLMN
OPQRST
UVWXYZ

Above: An example of the Versals alphabet.

Right: Drawn and painted Versal letterforms in watercolour and gouache on Saunders Waterford paper.

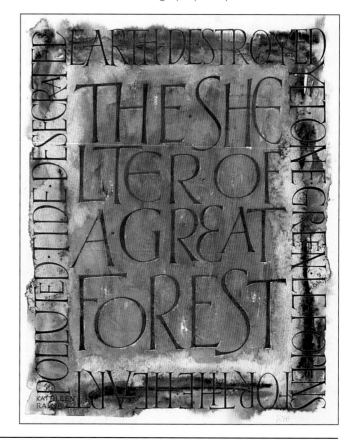

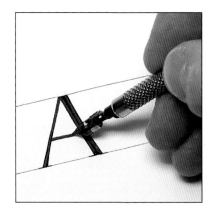

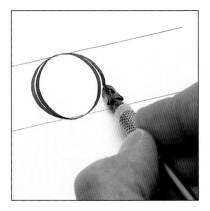

3 The first stroke of "A" is a single diagonal to the base line. Make a second stroke to widen the base of the stem. Finish with a horizontal stroke to form the hairline serif.

4 Make two strokes with the pen angle at 90° to their direction, leaving a gap between them. Draw this thick diagonal slightly top-heavy.

5 Complete the letter "A" with a thin cross bar made by moving the pen horizontally with its angle at 90° to its direction.

6 Draw the inner strokes of the circular forms first, with the pen angle around 10–15° to the horizontal. The outer circular movements leave the usual gap of about 1 nib width before filling in. Note that the top and base of such letters as "C", "G", "O" and "Q" (and the base of "U") will marginally exceed the guidelines.

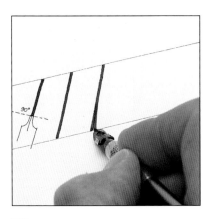

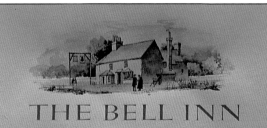

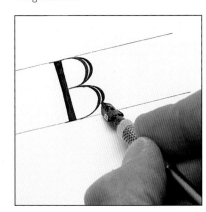

7 Draw the inner curves of "B", "P" and "R" first, with the pen angle parallel to the writing line. Make a second outer curve, leaving a gap of roughly 1 nib width. The lower bowl of "B" should be slightly larger than the upper one.

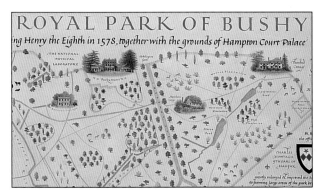

THE BELL INN

An early mention of this building was on the 20th December 1560 when the house known as 'Trollyes' was leased for 700 years at a rental of seven shillings a year.

In 1730 the house became an inn under the name of, and sign of, 'Ye Bell', the first licensee being Thomas Adams. In 1789 the Quaker brewer William Lucas of Hitchin granted a mortgage of £150 — to the licensee in return for the sole right to sell only Lucas's beer, but in 1808 Lucas was tricked into selling his interest at a low price to Arthur Dunn who then transferred the interest together with the Elizabethan lease to the Hoddesdon brewers Christie and Cathrow for £850.

Probably the inn's most important association was with the great English poet, author and essayist Charles Lamb (1775–1834). Lamb knew the inn from childhood until his death and was known to be a frequent customer. He regarded landlords Jonah Fordham, Simon Clarke and Arthur Dunn as his friends. He referred to the village of Widford and the Bell Inn in his autobiographical book 'Confessions of a Drunkard', published in 1813. On occasions after visiting the Bell, he is reputed to have ducked his head in the age-old trough which stood to the right of the front door, to clear his head and eyes before his long dark walk to Widford Mill.

When in 1827 Lamb was asked to submit a portrait of himself to illustrate Leigh Hunt's 'Lord Byron and some of his Contemporaries', he replied, 'As to my head it is perfectly at your, or anyone's service – I should be proud to hang up as an alehouse sign even'. There can be little doubt that the alehouse to which he referred was the Bell Inn at Widford.

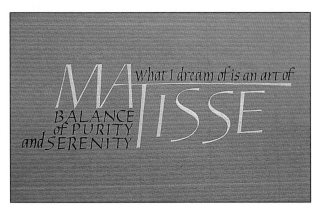

Top: Decorated map of Bushy Park (detail) with Versals.

Above: Freely drawn Versals dominate this quotation which uses designer's gouache on Fabriano Ingres paper.

Left: Stick ink, designer's gouache and watercolour on Watford paper are used for this piece.

Gothic Script

Gothic Script was developed in the twelfth century and predominated in Germany, France and England until the fifteenth century. It is often referred to as "Black Letter" and some of the styles are known as "Textura". The shift from curved letters to an angular form where the rigid verticals were pushed close helped save space in bookmaking. At its most formal, Gothic is not very legible, but modified versions can look equally dense and ornate. The capitals are more rounded than the minuscules, and can be highly decorated. For reasons of legibility, words should not be written in capitals alone.

Use a pen angle of 40° to the writing line and an x height of 5 pen widths. Ascenders and descenders should extend a further 2 pen widths and the capitals are drawn at 6 pen widths.

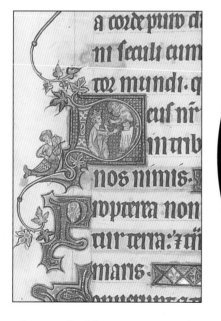

Above: A highly ornate example of the Gothic Script from a 14th-century manuscript.

Above: This beautifully composed logo is executed in personalized Gothic Script.

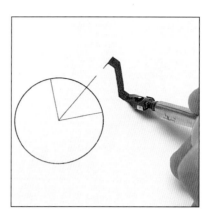

1 Use a 40° pen angle to make this common stem stroke, which moves in three directions without a pen lift.

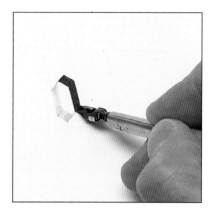

2 Link the second stroke of this shape by moving the pen diagonally and then vertically, maintaining the 40° pen angle.

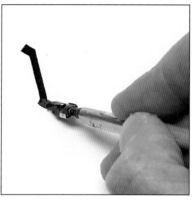

3 Form the diamond-shaped base of vertical stems with a small diagonal stroke.

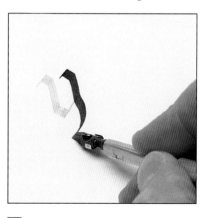

4 Make this stroke with a swift pen movement at a sustained angle of 40°.

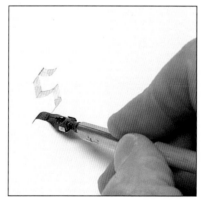

5 Draw the stroke at the base of the letter "s" with a short, curved clockwise movement.

6 Use a downward movement to complete the letters "y" and "g".

A B C D E F G H I J K L M
N O P Q R S C U V W X Y Z

a b c d e f g h i j k l m
n o p q r s t u v w x y z

Above: Upper case and lower case alphabets in Gothic Script.

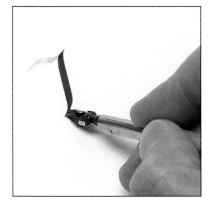

7 This initial flowing movement begins many of the capital letters.

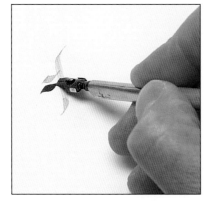

8 Many of the capital stems are formed using this subtle snake-like movement, but you should resist the temptation to overdo the wave.

9 This small "finishing" movement is used to decorate some of the stems of the capitals.

10 Use this base flourish to enhance the shape of the capital "L".

11 This abrupt pen movement, forming the base of the capital "S", is used in many of the capitals.

Handwriting

Good handwriting could be described as a less formal but more fluent version of the Italic Hand. Essentially cursive, it should be legible and written with reasonable speed. The two kinds of letter joins, diagonal and horizontal, play an intrinsic role in the pattern and rhythm you should aim to achieve.

You can use a dip pen or a fountain pen, but do not select too wide a square edge. Anything less than 5 nib widths will restrict the continuous movement of the writing. Writing with a pen that produces a monoline – such as a felt-tipped or ball-point pen – can be just as attractive: the letter shapes and the rhythmic bands of writing on a page with generous, well considered margins are visually more important than the thick and thin strokes of the letterforms.

Above: This reply to a wedding invitation uses a Post Office pen with white gouache on G.F. Smith mould-made paper.

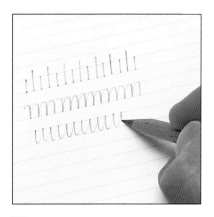

1 Sit comfortably, leaning slightly forward, and hold the pen lightly between your thumb and first finger with your second finger giving support underneath. This grip should encourage a good pen slope and ensure the pen is not too upright.

2 Begin by practising with a soft pencil on narrow-ruled paper.

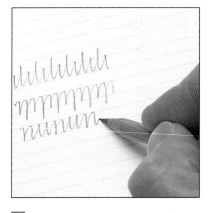

3 Create rhythmic bands of pattern at a consistent slope. It will not be difficult to recognize the beginnings of letters.

4 Practise letters similar to the bands of pattern, using "mumbo jumbo" words. Be careful to make the correct horizontal and diagonal joins.

Right: Letterforms in a handwritten style.

ABCDEFGHIJKLMNOPQRST
UVWXYZ 1234567890
abcdefghijklmnopqrstuvwxyz

maintaining

and the man

▲ 2 x heights
between lines
▼

Word spacing

Above: These two lines show the spacing you should aim for between lines of writing and between words: allow one "letter space" the width of an "o" between one word and the next.

Above: Layouts for a single page and a double page of handwriting. Lines of writing should not start and finish at the extreme edges of the page. The appearance is greatly improved by the allowance of generous white margins.

Thou shalt know Him
When He comes
Not by any din of drums
Nor the vantage of His airs
Nor by anything He wears
Neither by His crown
Nor His gown
For His presence known shall be
By the holy harmony
That His coming makes in me

Above: This piece, written in brown ink with a dip pen on hand-made paper, demonstrates the importance of margins.

Below: The handwriting of the calligrapher John Shyvers.

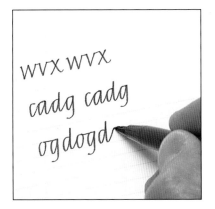

5 A felt-tipped pen with a narrow square edge has been used here.

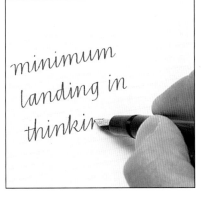

6 When you feel ready, use a dip pen with a narrow square edge, or a fountain pen, and begin to put words together. Check that you are familiar with all the letterforms.

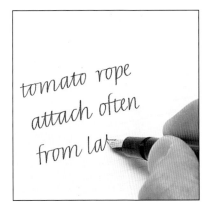

7 Try to keep the letters a consistent height. Keeping the tops of the letters at a uniform height is especially important to legibility.

Writing is for us the m
universal of the Arts, a
craftsmen have to deal
lettering of a more form
It is a commonplace of h
criticism to point out how
the Italian artists owed to
general practice amongst
of goldsmith's work, a cr
required accuracy and delic
hand. We cannot go back
but we need a basis of tr
in a demonstrably useful
and I doubt if any is so

Copperplate

To simulate the copper-engraved letterforms reproduced in the numerous copy-books of the eighteenth-century writing masters, quill pens were cut to a fine point, and the thick and thin strokes achieved by the engraver were imitated by varying the pressure on the pen. Today, this attractive script can be written with a flexible-pointed drawing pen (sometimes called a Post Office pen). Under pressure, the two blades that form the nib spread apart to make the thicker down-strokes.

Practice will give you the feel of the pen. Up-strokes are thin, down-strokes thick. Try to leave even spaces between the thick strokes, and ensure that the ascenders and descenders do not interfere with one another. Dilute the ink so that it flows easily through the pen.

TIP

When writing Copperplate, turn the paper anticlockwise (counterclockwise) so that you can make the sloping down-stroke using a vertical movement.

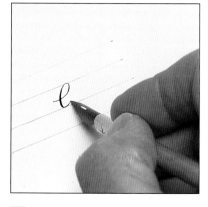

Left: A fine example of the Copperplate script.

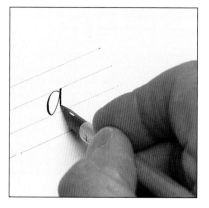

1 Make the "a" with an anticlockwise (counterclockwise) elliptical pen movement, exerting pressure on the down-stroke and lessening it on the upward stroke.

2 Make the up-stroke of "e" thin and the down-stroke thick.

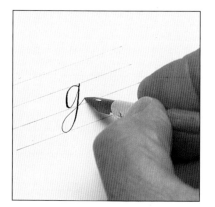

3 Copperplate descenders should be graceful loops.

4 Keep the down-strokes in letters such as "h" and "n" at a consistent slope.

5 Keep the down-strokes of "m" at a consistent slope and ensure that they are evenly spaced.

6 Base all the round lower case letters on this elliptical form.

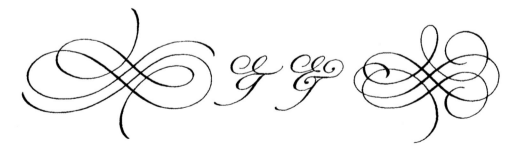

Left: Copperplate lower case alphabet.

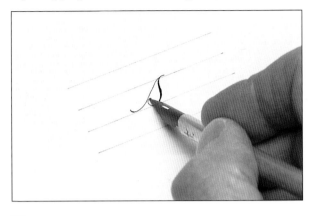

7 Produce a light and graceful pushing movement in the up-stroke of the letter "s" and an equally elegant pressure stroke on its return.

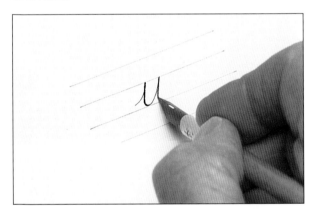

8 Make the up-strokes thin and the down-strokes thick.

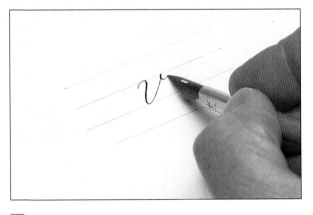

9 The "v" should have a rounded base.

Continued ⇒

Right: Copperplate upper case alphabet.

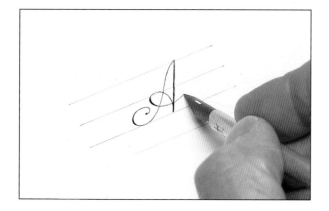

10 As with all down-strokes, that of the capital "A" is vertical. Remember, it is the paper that is tilted.

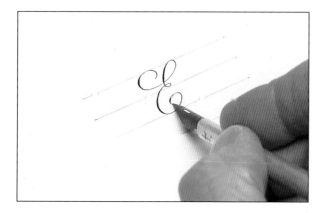

11 You can be extravagant with the spiralling movements of letters such as the capital "E".

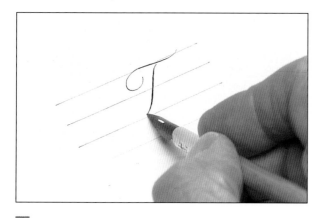

12 This movement forms the down-stroke of many Copperplate capitals.

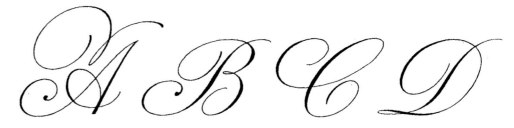

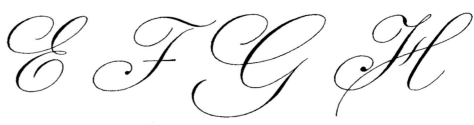

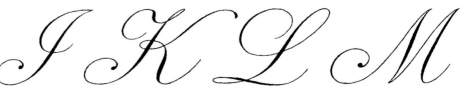

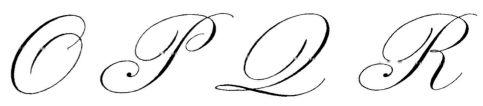

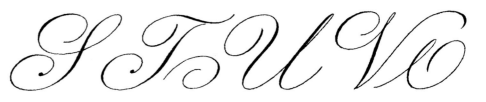

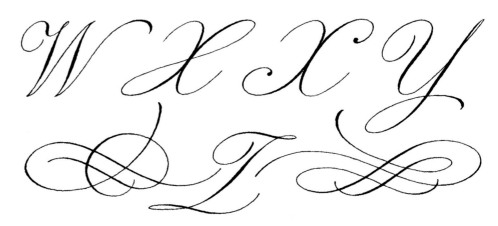

13 Maintain the elliptical shape when writing rounded capitals such as the letters "G" and "C".

14 Enjoy the figure-of-eight movement when forming the letter "L".

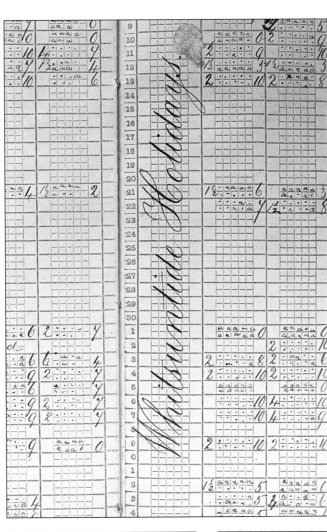

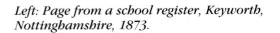

Left: Page from a school register, Keyworth, Nottinghamshire, 1873.

Below: USA postage stamp.

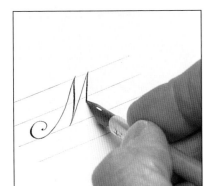

15 Produce letterforms like this capital "M" with authority.

16 Ensure you achieve the full strength of the letter "Q" by avoiding any dents or flats in its spiral.

17 Try to keep all the thick down-strokes parallel.

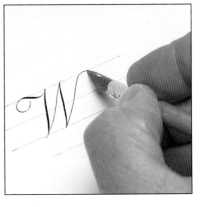

18 Make a flourish into and out of the letter "W".

Script Pen and Monoline Lettering

Calligraphy need not be confined to lettering with a square-edged writing instrument. Script pens (sometimes known as "ball pens") and other writing tools produce monoline letters – the strokes are of equal thickness, regardless of the direction in which the pen moves.

An appreciation of the skeleton alphabet is a starting point to work of this kind, which can be beautiful in its simplicity and is especially useful for posters, commercial work and a wide variety of cards. With practice, such lettering can be handled fairly swiftly and with confidence, the "urgency" of some styles contributing to their attractiveness.

Except mid week zippy hovercrafts jockey along beside quays

CHILDREN'S PARTY
with Mr Abracadabra

S C H O O L L I B R A R Y

RESTAURANT

Eight quaint jovial zebras could wake my playful fox

BY KIND PERMISSION OF THE
Coach departs Tennyson Ave.

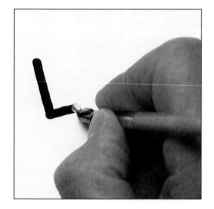

1 Incline a script or "ball" pen so that the mark-making part of the nib lies flat and is wholly in contact with the writing surface as it moves across it.

2 When using a large rounded-end felt pen, remember to keep the letterforms simple and with good shape and proportion. New fully loaded pens tend to bleed on some papers, while pens that are running out can produce interesting effects.

3 A fine-tipped felt pen can be used for monoline work. Make the circular shapes in one or two movements, depending on the size of the letters.

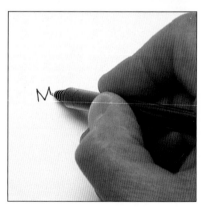

4 When using a rollerball pen, produce the letters slowly and carefully, with a deliberately correct sequence of strokes and pen lifts.

Opposite and below: Samples and developments of monoline lettering.

Right: A Christmas party invitation designed simply by pasting down strips of information with a Christmas card.

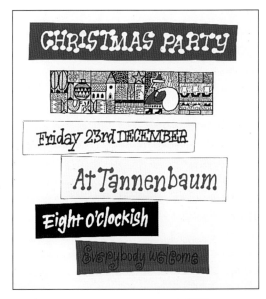

Jackdaws love my big sphinx of quartz

ABCDEFGHIJKLMNOPQRSTUVWXYZ

THREE ZEBRAS CLUB

THE QUICK BROWN FOX JUMPS OVER THE LAZY DOG

About sixty cod fish eggs will make a quarter pound of very fizzy jelly

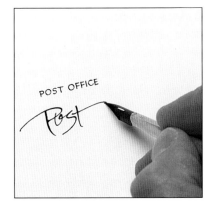

5 A drawing or Post Office pen is the most common form of drawing pen. Unless pressure is exerted, a consistently fine even line is made, regardless of the direction in which the pen moves. Press on the nib to produce thicker strokes and to "scribble" attractively. A slip-on reservoir can easily be attached to this type of pen.

6 Draw very fine, accurate guidelines before using a Rotring pen. Writing attachments can be obtained in extremely fine sizes. Very small lettering is best accomplished under a desk magnifying glass.

7 A metallic silver marker on a dark background creates highly attractive results. Silver and gold markers are made in various sizes. They are easy to use for quick showcards, but also effective in more sophisticated contexts.

8 A brush well charged with ink or colour will produce opaque, clean lettering. Working on dark paper with a contrasting, light colour is very effective.

IHEFLT AMNVWXZKY OQCG

UJDBPRS 123456789 &

Lowercase bdfghijklmnpqtuvxuz

Right: A typical example of a monoline alphabet.

Layout and Spacing

As well as individual letterforms, the calligrapher must be concerned with the space around and between letters and words in order to produce writing that is both legible and visually pleasing. Layout and spacing of the written words is crucial to the success of a piece of work.

Letter spacing

Letter spacing concerns the way in which the letters of each word combine into a satisfying whole. Effective spacing is not simply a case of leaving the same gap between each letter. The space inside letters and the varying spaces around straight or curved letters also have to be taken into account, so your eye is usually the best judge. As a guide, place adjacent straight-sided letters furthest apart, rounded letters closest together and allow a medium space between a curved letter and a straight-sided one. Alternatively, establish the distance between the first and second letters, then position the third letter so that the second sits comfortably between the first and the third.

SEMINAR

SEMINAR

Above: Leaving an equal gap between each letter in this word (above) results in an unsatisfactory arrangement. The amended version (below) is much more pleasing.

TIP

Whatever piece of calligraphy work you are designing, it is useful to write the main words first, then design the subsidiary lettering to complement them.

Spacing between words

Inter-word spaces should be wide enough to differentiate clearly between words, but not so wide that the eye has to jump from one word to the next. They should approximate to the width of the letter "o" in the script being used.

Spacing between lines of writing

This will vary according to the nature of the work. A helpful starting point is a measure of two x heights. Allowing less space than this can be attractive, but where lower case letters are involved you will need to avoid a clash of ascenders and descenders. Writing in lines of capitals doesn't present this problem, and interlinear spacing can be narrow.

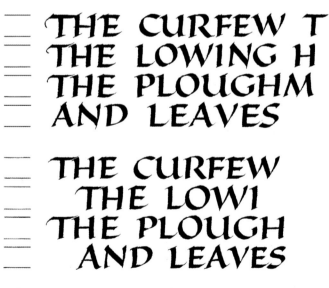

Not a drum was heard, not a f
As his corpse to the rampart w
Not a soldier discharged h
O'er the grave where our

Above: The width of the letter "o" is used to gauge the spacing between words, while the spaces between the lines of text measure twice the x height.

THE CURFEW T
THE LOWING H
THE PLOUGHM
AND LEAVES

THE CURFEW
THE LOWI
THE PLOUGH
AND LEAVES

Above: If you are writing in capitals, a narrow space between the lines is effective. Try to avoid "rivers" of white space (above), which arise when word spaces fall in a similar position in successive lines. The solution has been resolved in this case by indenting alternate lines (below).

Margins

Be generous with margins, as surrounding space makes a crucial contribution to your design. Professional mounting and framing will further enhance your work.

Text may be centred to produce a symmetrical layout, or written with a justified margin on the left or right. Justifying on the right presents the greatest challenge – with capitals it is possible to work backwards from the margin, but if lower case lettering is used, you will need to write a rough and place it just above your work as reference.

Paper size

The size of paper you will need for a piece of poetry can be calculated by adding the measurement of the planned heading, the sum of the x heights of all the lines, the line spaces, any credits and the top and bottom margins. The width of the paper can be gauged by writing the longest line. If you need to fit a piece of writing on to a given size of paper, this method is indispensable. A calculator will speed up your planning.

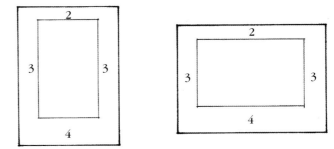

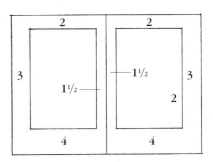

Above and right: When designing a single sheet, the proportion for the margins is 2 at the top, 4 at the bottom and 3 either side, whether for portrait or landscape format. In a book, the visual unit is a double page (right). The inner margin of each page should be 1¹/₂ and the outer margin 3.

Left: Using a margin within the text with a "vignette" effect at the sides may be appropriate for such text as a translation on a menu or the cast of a play.

Below: The layout of this birthday card in designer's gouache on Fabriano Roma paper is as important to the finished look as the lettering quality.

1 Producing a card for reproduction may be achieved by sticking down strips of text. A centred or symmetrical layout is easily effected this way.

2 Always use paper or card larger than is necessary. Establish margins by using strips of card.

Copying, Tracing and Scaling

If you are writing a commemorative address or a formal document such as a certificate, it may include a heraldic device, emblem or badge. You may need to rescale its design, and a photocopier with a reducing and enlarging facility makes this simple. But if you do not have access to a photocopier, or if the original is very large, use the "squaring off" method. An alternative is to project a transparency on to paper and trace the image. Once the design is the size you need, trace it on to your paper. If you have a lightbox, the image can be carefully placed and traced through directly.

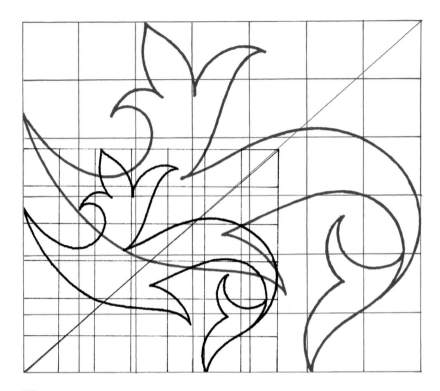

1 Make an enlargement by extending the diagonal of the picture. At any point along this diagonal a line drawn at right angles to the bottom line will give a new picture size. Divide both pictures into the same number of squares. The marks within each small square of the original can then be transferred to the corresponding square of the copy.

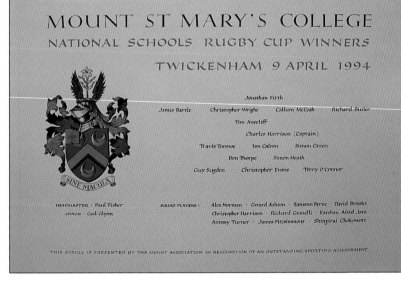

Above: Formal calligraphic work often includes heraldic motifs. This piece was done in stick ink and designer's gouache on Pergamenata paper.

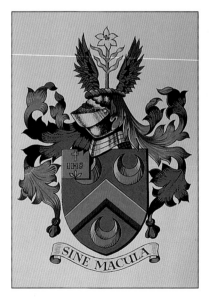

Above: Detail of insignia for Mount St Mary's College.

2 Using a sharp pencil, trace the outlines of the design on to tracing paper.

TIP

If the design is symmetrical, the tracing paper can simply be turned over and traced through in its correct position, bypassing the "scribbling" stage.

Right: This work is done in stick ink, gouache and raised gold on vellum.

Far right: These three detail pieces are lovely examples of badges, emblems and plumes typical of formal calligraphic work.

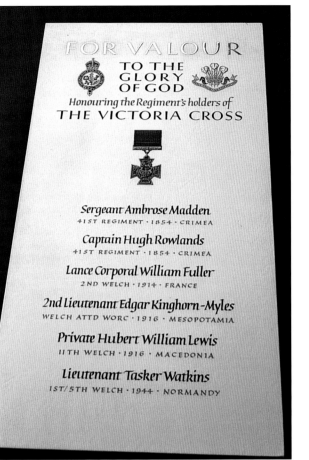

FOR VALOUR

TO THE
GLORY
OF GOD

Honouring the Regiment's holders of
THE VICTORIA CROSS

Sergeant Ambrose Madden
41ST REGIMENT · 1854 · CRIMEA

Captain Hugh Rowlands
41ST REGIMENT · 1854 · CRIMEA

Lance Corporal William Fuller
2ND WELCH · 1914 · FRANCE

2nd Lieutenant Edgar Kinghorn-Myles
WELCH ATTD WORC · 1916 · MESOPOTAMIA

Private Hubert William Lewis
11TH WELCH · 1916 · MACEDONIA

Lieutenant Tasker Watkins
1ST/5TH WELCH · 1944 · NORMANDY

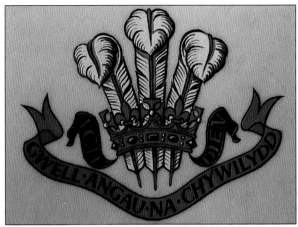

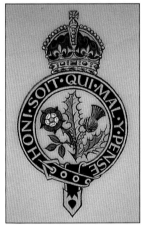

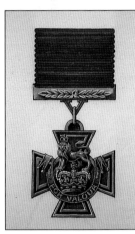

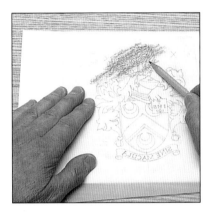

3 Turn the tracing over and scribble with an HB or B pencil over all the traced lines.

4 Place the tracing paper (positive side up) in the correct position and trace through the design using a sharp, hard pencil (such as 4H).

5 Redraw the motif using a fine pen and waterproof ink. Use a guard sheet to protect the design. Erase the pencil lines.

6 Colour the design and add the details using designer's gouache or watercolour and a fine-pointed brush.

Resist Techniques

Quite a number of effective ways of lettering involve the use of resist techniques. Just as hot wax drawn on fabric protects it from the dye in the batik process, letters (and other images) can be protected on paper. Use a wax crayon, sharpened wax candle or oil pastel, all of which will reject watercolour or water-based ink when brushed across the surface. Masking fluid, a rubbery solution, protects the surface very well and leaves clean edges. It can be used with a dip pen, an old brush or a stick of balsa wood. Masking tape pulls easily away from the paper, and can be cut into simple shapes or used to frame a background. Spray paint and felt-tipped pens can be used over masking fluid and tape. If you are using watercolour, you may need to stretch the paper first.

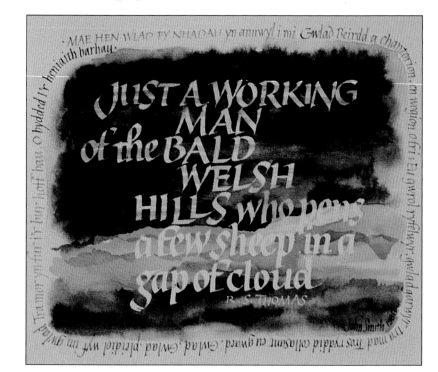

1 Wax crayons are most effective when the lettering is in light, bright colours. Write firmly in crayon on fairly smooth cartridge paper.

2 Brush water-based ink across the lettering, which will then stand out cleanly from the background.

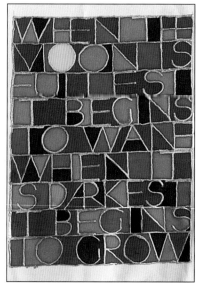

Above: Deka-silk work uses the same principle as other resist techniques, except coloured dyes are applied to the silk fabric.

Left: This text was written in masking fluid and a watercolour wash was then applied over the top. Additional lettering is in gouache.

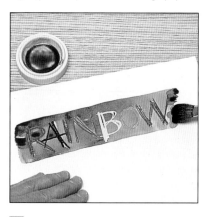

3 Oil pastels can be used like crayons. Again, use fairly smooth cartridge paper.

4 Brush a strong watercolour wash over the lettering to form the background colour.

5 Masking fluid should be fed into a pen using a brush. It dries quickly, so work fast and clean the pen and the brush frequently. Use an old brush that can be cleaned in hot soapy water.

6 When the masking fluid is dry, decide on the margins around the text and frame it with strips of masking tape.

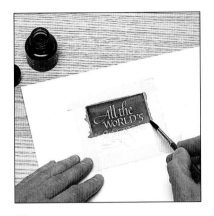

7 Brush a strong wash of water-based ink, watercolour or gouache over the lettering, allowing the wash to overlap the masking tape frame.

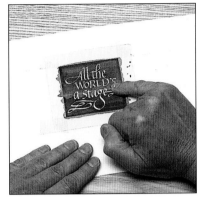

8 When the wash is thoroughly dry, the masking fluid can be carefully rubbed away with your finger to expose the paper underneath.

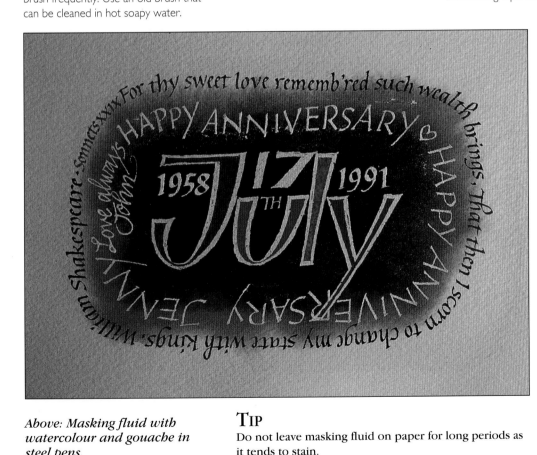

Above: Masking fluid with watercolour and gouache in steel pens.

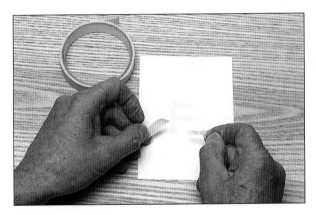

9 Build up simple letter shapes using strips of masking tape.

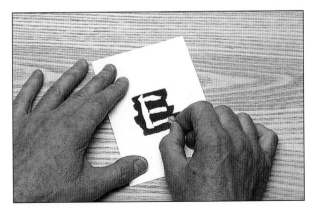

10 Paint over the taped image with a wash of colour. Allow the paint to dry thoroughly before carefully peeling off the tape.

TIP

Do not leave masking fluid on paper for long periods as it tends to stain.

Scraping Out and Bleaching Letters

Interesting effects can be achieved by scraping, carving, embossing or bleaching letters out of their backgrounds. For example, layers of oil pastel or coloured crayon can be scraped away to reveal the paper colour or previous layers of colour.

SCRAPING OUT

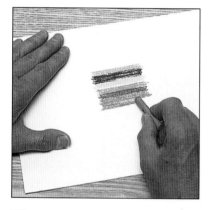 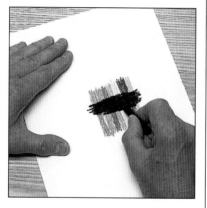

1 Fill the background area with stripes or patches of oil pastel colour (or coloured wax crayon), working on fairly smooth cartridge paper.

2 Cover the coloured background with a block of black oil pastel colour (or black crayon).

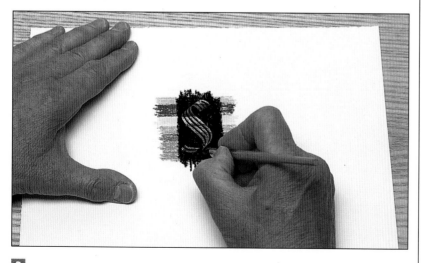

3 Use a broad nib to scrape through the black and expose the colour underneath.

BLEACHING OUT

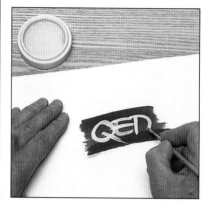

1 Brush some blue fountain pen ink in a broad band across the paper. While the ink is still moist, create confident brush letters using neat or diluted bleach and a nylon brush. Be careful not to get any bleach on skin, clothes or furniture.

2 The same technique can be employed using a pen. Brush on fountain pen ink as before, allow to dry, then charge a square-edged pen with bleach to draw the lettering.

 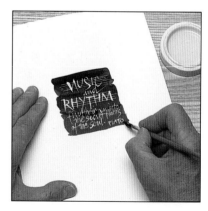

3 If you brush on three colours of fountain pen ink, they will produce an interesting effect where they meet.

4 Use two different sizes of pen nib charged with bleach to create the lettering and the effect of music manuscript paper.

Below: Brush lettering in coloured inks has been over-written in pen and bleach for a secondary message.

Right: An embossed Latin inscription on 600g hand-made paper.

Below right: Stick ink and gouache on hand-made paper with a central embossed area.

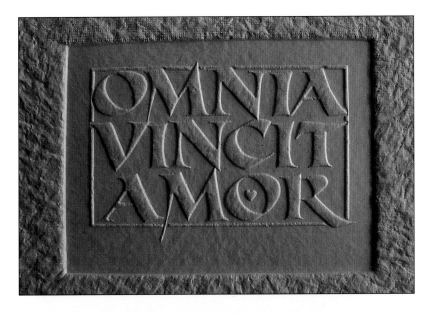

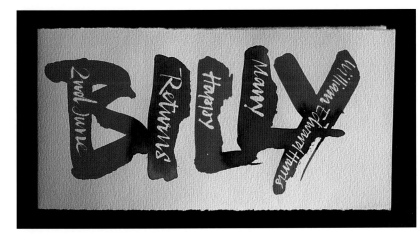

SCRAPERBOARD

1 Scraperboard is a board covered with white clay and has a black surface layer that is scraped away to expose the white underneath. Write on a piece of scraperboard using a wide nib, then, with the resulting marks as a guide, produce the lettering with a scraper pen or other sharp-pointed tool.

EMBOSSING

1 Embossing involves raising the surface of the paper by pushing it into reversed, incised letters which have been cut in either lino (linoleum) or cardboard. Here a burnisher is used to push the dampened paper into indentations cut into lino.

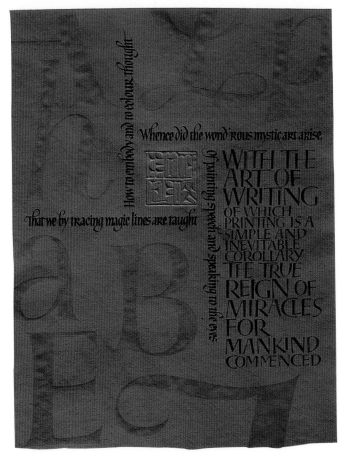

Experimental Lettering

Experimenting and exploring many of the approaches used in drawing and painting can lead to a wide range of effective results in lettering. The techniques demonstrated here are enjoyable starting points for experienced calligraphers as well as beginners. There are many more to discover for yourself.

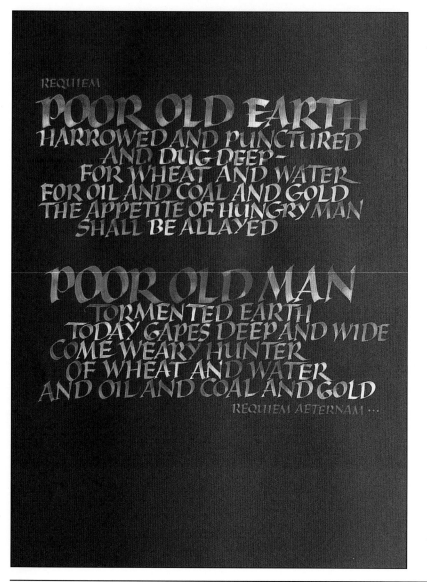

BLENDING

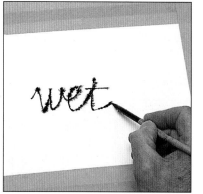

1 Stretch a sheet of paper on a drawing board. While the paper is still wet from being stretched, write quickly in ink using a pen or brush.

2 Achieve this lovely watercolour effect by writing letters in water, one at a time, with a pen. Using a small brush, touch the letter with different colours, allowing them to fuse naturally.

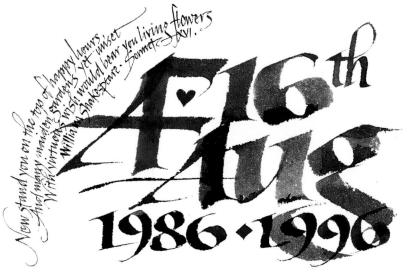

Left: Blended gouache coloured capitals were produced on G. F. Smith mould-made paper.

Above: Watercolour on mould-made paper with an automatic and a small steel pen.

POOLING

1 Write letters on a steeply inclined drawing board with a well-charged pen so that the base of each letter collects a "pool" of tone.

SHADED LETTERS

1 To create shaded letters, mix two colours of gouache next to each other on a palette or dish. Stroke a wide-edged brush across both colours so that each is mainly on one side of the brush. The resulting lettering will have an interesting three-dimensional effect.

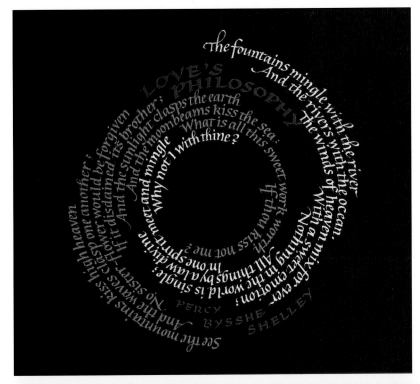

Left: Concentric circles create a spiral effect in the harmonious arrangement of this poem. It is worked in designer's gouache on G.F. Smith's mould-made paper.

Below: Light coloured letter-forms on a dark background work well here. The brush lettering in white gouache is on black sugar paper.

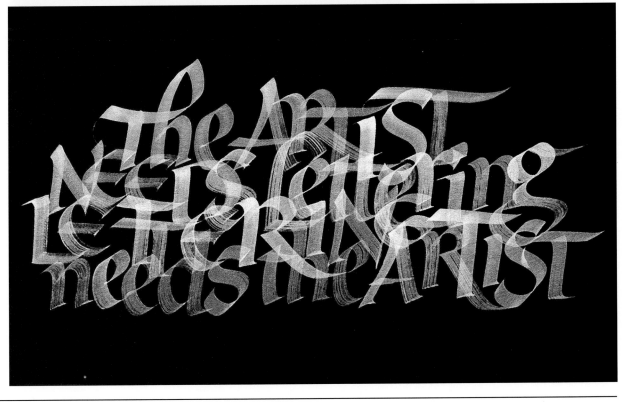

Experimental Letter Shapes

Letter shapes and their endless permutations hold enormous design potential, using variations in size, the interplay of capitals with lower case letters and negative shapes. Such work relies more on "picture" quality than legibility for its impact. It lends itself well to printmaking. Many artists concentrate more on the pictorial quality of letterforms if they work in reverse.

Collage is an attractive way of producing such items as display notices and posters. The materials required need not be expensive if you save magazines, scraps of fabric, used tickets, wrapping paper and wallpaper. Simple letters may not need to be drawn before you cut them out – bold letters will result from confident strokes of the knife. Aim for contrast – decorated letters on busy backgrounds will be ineffective.

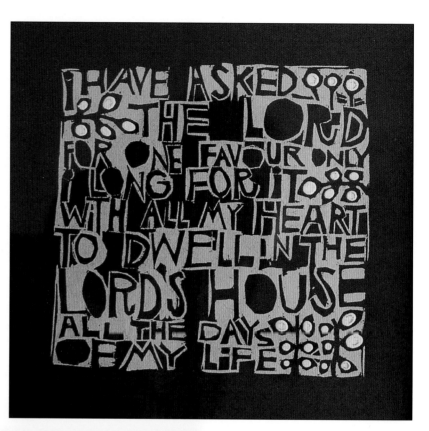

Above: This hardboard surface print has been done on Japanese paper with acrylic colour added.

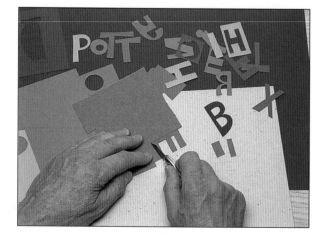

1 Cut simple letter shapes out of a harmonious range of coloured papers using a sharp craft knife. Retain the counter-shapes as well. Drawing the letters on the back of the paper will avoid pencil marks on the shapes, but they will have to be sketched in reverse.

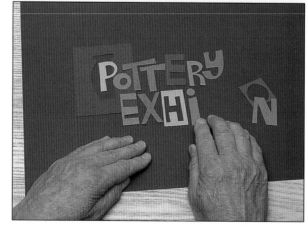

2 Push the letter shapes around until you are happy with the composition. Don't stick anything down until your arrangement is complete – mark the positions if the design is complicated. Always begin with a larger background than you think necessary, and trim the edges when your design is finished.

TIP

Choose the most appropriate adhesive for the materials you are using – even cold water paste is adequate for newsprint and paper. Spray adhesive is easy to use but a little expensive. Double-sided adhesive tape and sticks of glue are handy. Self-adhesive coloured labels that can be cut into letter shapes are perfect for this "applied" technique.

Top line: Collage work is an effective way of making pictures from letter shapes.

Right: Positive and negative letter shapes contribute to the effectiveness of this screen-printed poster.

Far right: Letter shapes have been used to create an attractive border for this screen-printed Christmas card on Japanese paper.

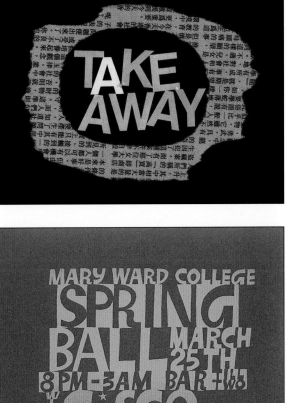

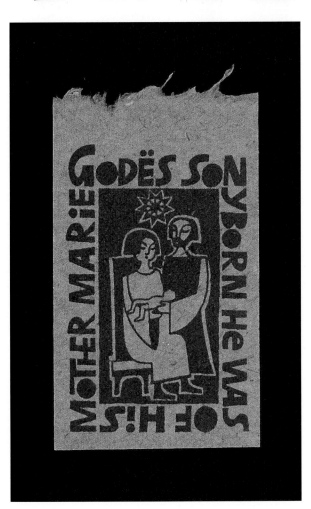

Stencil and Spray

Bold letter shapes make perfect stencils for spray painting. As with collage, both positive and negative shapes can be used to create images that take the design qualities of background spaces into account. An airbrush is ideal, but the cheaper substitutes are also effective. Cans of spray paint are usually oil-based, so protect surfaces carefully: this work is best done in a garage or shed. The design illustrated was produced with an inexpensive spray diffuser. The ink may be water-based or waterproof, and dye is also a suitable medium.

1 Draw the letter shapes you will need on thin cardboard and cut them out carefully using a sharp craft knife.

2 Thin card or paper will curl up when sprayed, and has to be pinned down to obtain a sharp image. Lay a sheet of fairly strong absorbent paper on a piece of cardboard, lay out the letters and, when you are happy with the arrangement, pin them down using dressmaker's pins.

3 To use a spray diffuser, place the longer of the tubes in a bottle of ink. Keep the other at right angles while you blow through it to deposit a spray of colour over the letters.

4 When the ink is dry, remove the letter shapes to expose the protected images underneath.

Above: Experiment with the diffuser when you are planning your design, to judge the effects of mixing different coloured inks.

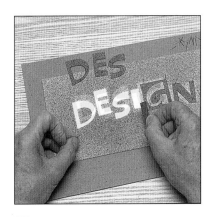

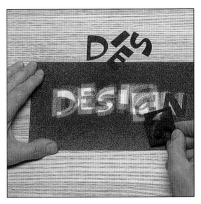

6 Remove the letter stencils to expose the protected letter shapes. Rearrange the letters a third time and pin them down. Then spray over the design with a third colour.

7 Finally, remove the letter shapes to reveal the finished design.

5 Rearrange the letter stencils and pin them down again for a second spraying, this time with a different coloured ink.

Above: Heavy items such as pieces of scrap metal make ideal stencils for spray paint.

Above: Successive layers of ink in a single colour give a subtle shadowy effect.

Paper Print Quotation

This simple relief printmaking technique uses the raised surface of paper cut-outs and lends itself well to letter shapes. Negative shapes can also be incorporated into your design if you wish, and you can add variety to the print by using materials such as textured paper, relief wallpaper or muslin. Remember to assemble the design in reverse on the cardboard base.

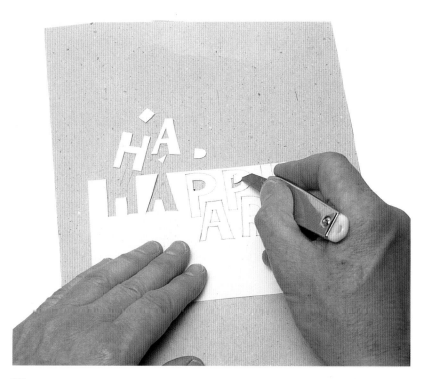

MATERIALS
paper
pencil
photocopier
craft knife
cutting board
adhesive
cardboard
coloured printing ink
glass sheet
palette knife
ink roller
bone folder

glass sheet

coloured printing ink

bone folder

craft knife

pencil

palette knife

paper

adhesive

ink roller

cutting board

1 Make a rough sketch of your design. To retain the liveliness of this first sketch, enlarge it on a photocopier.

2 Draw the individual letters on a sheet of fairly thick paper. Using a sharp craft knife, carefully cut out the shapes on a cutting board.

TIP
Water-based printing inks can be cleaned up easily with water, but tend to dry quickly during the process of printing. Oil printing inks will remain workable for longer, but the cleaning up will require white spirit or turps substitute.

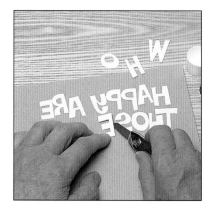

3 Arrange and stick down the letters in reverse on a suitably sized piece of stout cardboard. Cut out narrow strips of the paper you used for the letters and stick them around the edge of the design to make a border.

4 Squeeze a blob of printing ink on to a glass sheet. Mix and spread it out with a palette knife. Roll and lift the ink roller to spread the ink evenly. If you are using two colours, keep them separate and use a different roller for each.

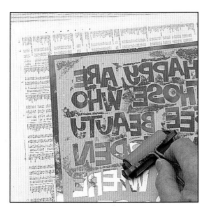

5 Roll the inks across the surface of the "block". Allow the two colours to blend in places.

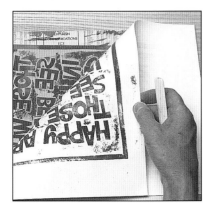

6 Place a sheet of thin paper over the inked-up surface and rub all over the back of the sheet with a bone folder or the back of a spoon. Pick up one corner of the paper, lift it off and leave to dry.

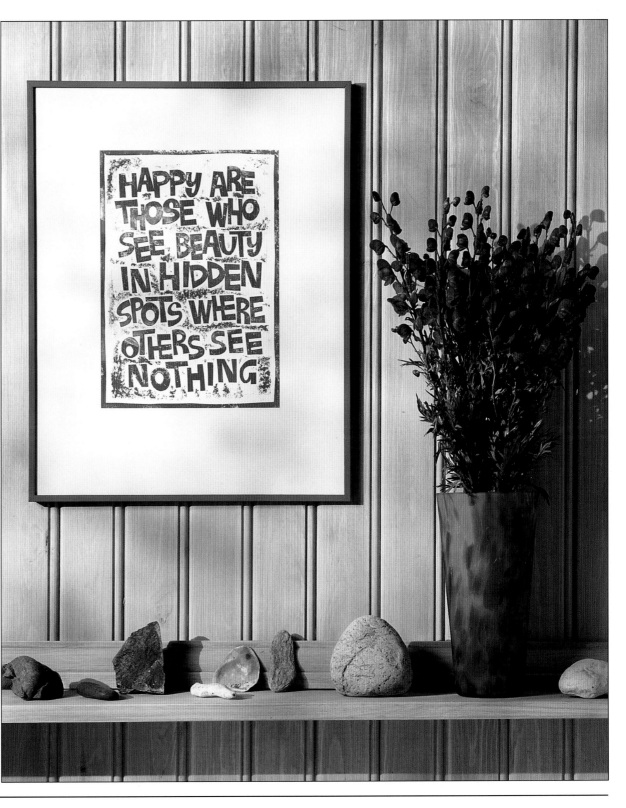

Embossed Menu Cover

Embossing can create a very sensitive quality in lettering. Like relief sculpture or carved letters, it relies on light and shadow for its attraction. It has many uses: a simple embossed motif or initial could be combined with calligraphy to enhance a well designed page, or a small embossed quotation could stand alone. The process involves raising the surface of the paper by pushing it into reversed, incised letters, which are usually cut in either lino (linoleum) or cardboard. Since a better impression is achieved on damp paper, using cardboard risks softening the template. Cardboard is perfectly adequate for producing one or two impressions but a lino template is virtually indestructible.

MATERIALS
HB and 4H pencils
paper
ruler
tracing paper
lino (linoleum)
masking tape
craft knife
thick paper, for embossing
burnisher, bone folder or large
 knitting needle
coloured cardboard
adhesive

burnisher

coloured cardboard

soft pencil

hard pencil

lino (linoleum)

craft knife

ruler

1 Draw out the word, in this case "Menu", on a sheet of paper and trace it on to tracing paper. "Scribble" with white pencil on the positive side of the tracing paper.

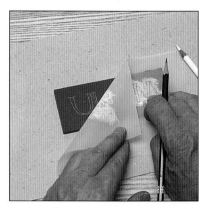

2 Turn the tracing over and position it on lino (linoleum). Fix it temporarily with small pieces of masking tape if necessary. Using a hard pencil, trace through the reversed image on to the lino.

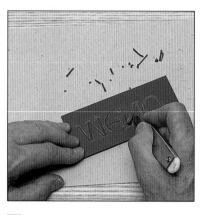

3 Using a sharp craft knife, carefully cut away the letters, ensuring that the incising is done with a "V" shape and that you do not undercut the edges of the letters, which would weaken them.

4 Dampen a piece of thick paper, position it over the letters and, very gently to begin with, push the softened paper into the indentations using a burnisher, bone folder or large rounded knitting needle.

5 When the embossed paper is completely dry, mount it on a folded sheet of coloured cardboard.

TIP
To dampen the paper, spray it lightly on both sides with a household water spray or immerse the sheet fully in water and absorb the excess with blotting paper or a clean towel.

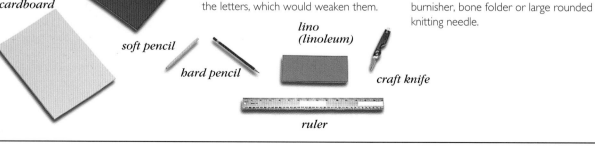

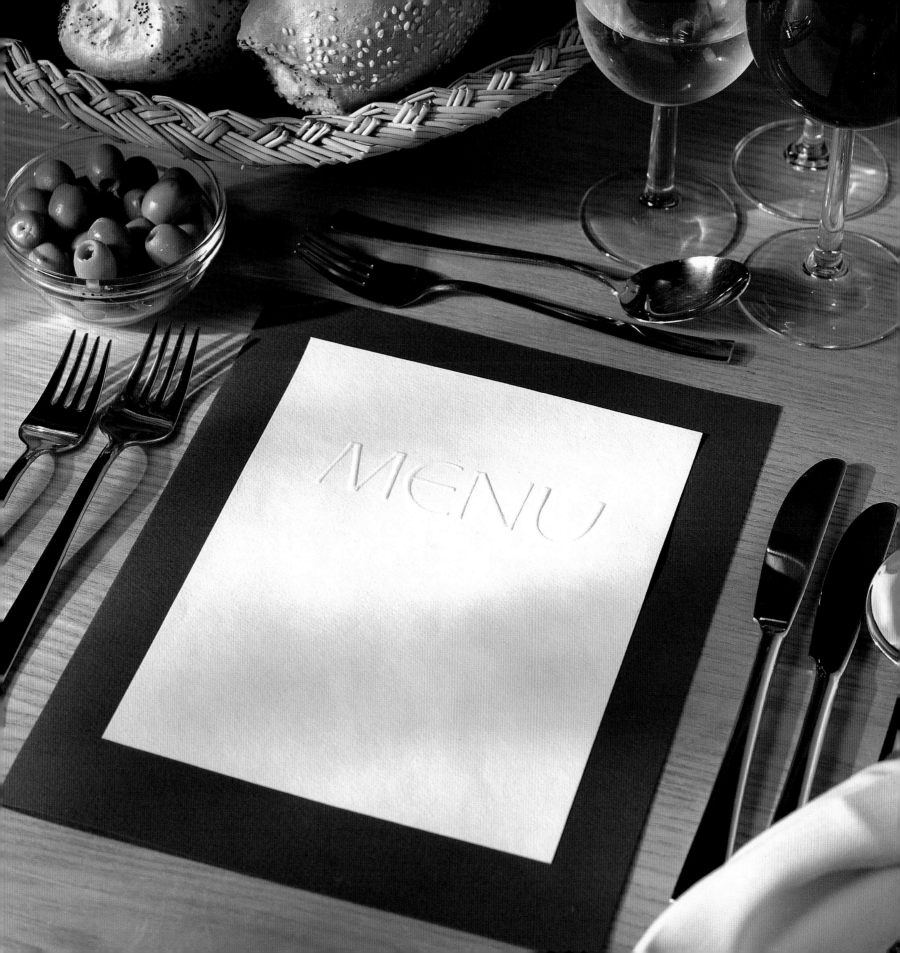

Potato-printed Gift Wrap

Potato printing is much underestimated and should not be left just to children. With good craft skills you can achieve very professional results. Potato prints are ideal for repeated patterns on endpapers or personalized gift wrap, but simple bookplates, monograms and logos are also easily produced this way. Experiment with second (and third) prints to reveal exciting "overprint" effects; subtle results can be obtained by using the same wash for the second "block". A fairly absorbent paper is the most suitable. Lay the paper on some flat sheets of newspaper to give more satisfying prints.

MATERIALS
paring knife
potato
chopping board
indelible pencil
paper
water-based colour
mixing dish
paintbrush

paper

paring knife

water-based colour

mixing dish

chopping board

paintbrush

potato

1 Use a thin-bladed knife to slice cleanly through the potato to produce a smooth printing surface. Trim the piece of potato to obtain a suitably sized chunk with a right-angled shape.

2 If you wish to draw the letter on the surface of the potato, use a sharp indelible pencil. Use the point of the knife to cut the letter (remembering that some letters will have to be cut in reverse). Retain the corners of the chunk of potato to aid registration of the repeat pattern. Avoid undercutting the design, which would weaken the surface.

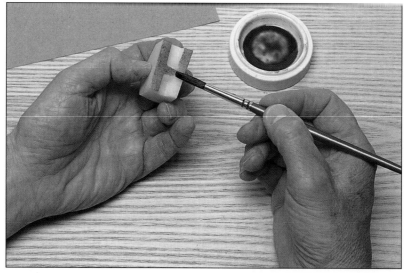

3 Draw faint guidelines on the paper to keep the pattern regular. Mix some well-diluted watercolour and brush it on to the printing surface of the potato. Apply more colour each time a print is made, but be economical with the wash: too much paint will produce an uneven, blotchy result.

4 Press the potato firmly down on the paper. Repeat the print evenly all over the paper, following your pencilled guidelines. Overprint with the same or another wedge of potato using a second colour of your choice.

Formal Calligraphic Poster

When you are commissioned to produce a calligraphic poster, it is wise to check the details. It is not unusual to be given a scrap of paper with surprising omissions like the time of an event or the ticket price. You must also find out the size and number of posters required. If reduction facilities are available, produce your master copy proportionately larger. Reduction reduces imperfections, but remember that very fine lines are liable to disappear. Once the poster has been photocopied, you may like to add a little colour to each copy with a felt-tipped pen.

MATERIALS
pencil
paper
metal ruler
pens
ink
craft knife
cutting board
strips of coloured paper
adhesive
photocopier
large felt-tipped pen

1 Draw a few rough sketches of possible arrangements. A symmetrical layout is a safe routine to start with, and this is the format described here.

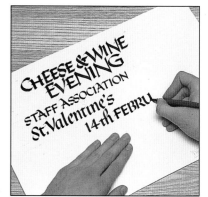

2 When producing lettering for the final draft, begin with the main heading. Since it will feature the largest lettering, this will establish the general proportion of the poster and govern everything else. For this line, it is a good idea to allow some slightly different sized capitals to "dance" between the guidelines, not only to give the words prominence but to create a less formal overall appearance.

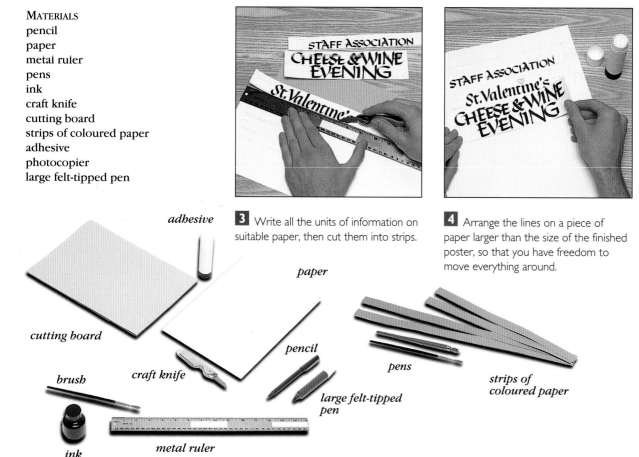

3 Write all the units of information on suitable paper, then cut them into strips.

4 Arrange the lines on a piece of paper larger than the size of the finished poster, so that you have freedom to move everything around.

adhesive

paper

pencil

pens

strips of coloured paper

cutting board

brush

craft knife

large felt-tipped pen

ink

metal ruler

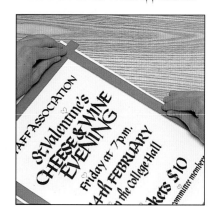

5 The edges of the poster can be determined by using strips of coloured paper. It is a good idea to work to a specific proportion, say for reduction to A4, when subsequent photocopying is simplified.

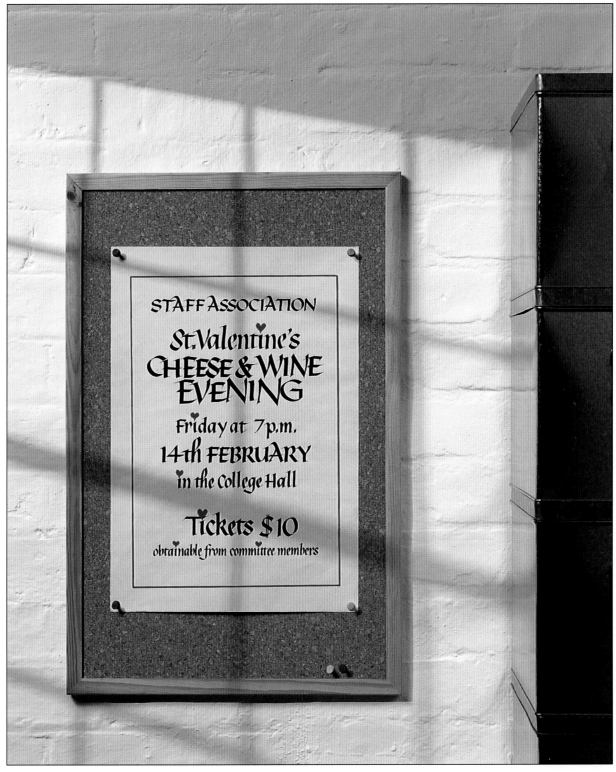

6 After photocopying, copies of the poster can be enhanced with a few touches of colour. A large felt-tipped pen is ideal for this operation.

TIP

If your poster is to be photocopied, there is no need to write it out again on a single sheet of paper: the "final rough draft" may be used as a master copy. Do remember, however, that the edges of the paper strips are likely to leave shadow lines and should be "whited" over. (This will also apply if the poster is to be professionally printed.)

Formal Headed Paper

The design of a letter head, business card and other stationery is quite a challenge. While this project is concerned with professionally printed stationery, remember that less formal letter headings can be produced using many of the techniques in this book and then easily printed on a photocopier.

MATERIALS
paper
pencil
ruler
pen
ink
white-out
brush

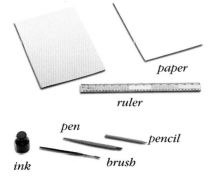

paper

ruler

pen

pencil

ink

brush

INSTRUCTIONS TO THE PRINTER:

25mm/1in solid block grey 427.4 bleeding off page.
"PHOTOGRAPHER" Helvetica Light 20pt caps in same grey.
"Michael Harris" reduced by 50% and half over-printed on to grey. Subsidiary lettering Helvetica Light 12pt and 8pt as indicated. Separate instructions should accompany other items, such as the compliments slip, invoice and business card.

1 Begin with some rough drafts. The nature of this business required a clean, focused design. The contrast of black on light grey reflects the mood of black and white photography and the partial overprint enlivens the lettering.

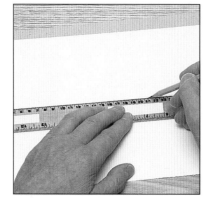

2 Before beginning the final piece, draw guidelines for your calligraphy and to show the position of any printed matter.

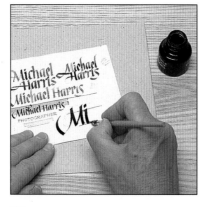

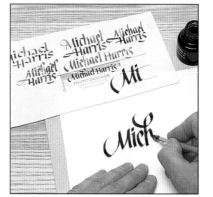

3 Write the client's name in pen and ink. Produce your artwork in intense black. Using white-out to mask any joins, you can make alterations if necessary.

4 Measure, draw and carefully paint the area to be printed grey, allowing 5mm/1/4in all around for the printer to trim the paper.

TIP

If the subsidiary lettering is also to be calligraphic, cut the lines of lettering into strips and paste them up. Remember that the printer can easily reverse an image, so if you want white lettering on a dark background, draw the lettering in black – the printer will simply print the background and leave your lettering white.

Writing a Certificate

Nothing impresses more, or is more sought after, than beautiful calligraphy on a formal certificate. Adding names to a professional certificate is simple, but there is an advised procedure.

MATERIALS
paper
pencil
metal ruler
pen
ink
craft knife
cutting board
scissors
certificates

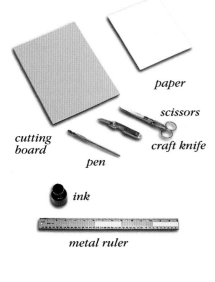

paper

scissors

cutting board

pen

craft knife

ink

metal ruler

TIP
If other information has to be inscribed, write each item – such as the date – on all the certificates at the same time. With experience, you will be able to start names of similar length on the typewritten list at the same point on the certificate.

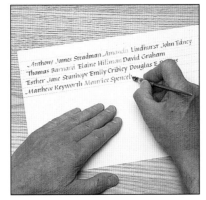

1 Estimate the size of your pen and write out the longest name on a strip of paper. Lay this in position on the certificate and if necessary re-write, adjusting your pen size. Draw guidelines to fit the space available on the certificate and write out the list of names. These need not be written to perfection, but the spacing is important. Use well diluted ink to save frequent cleaning of the pen.

2 Cut the names into strips and snip off individual names with scissors to act as guides to spacing.

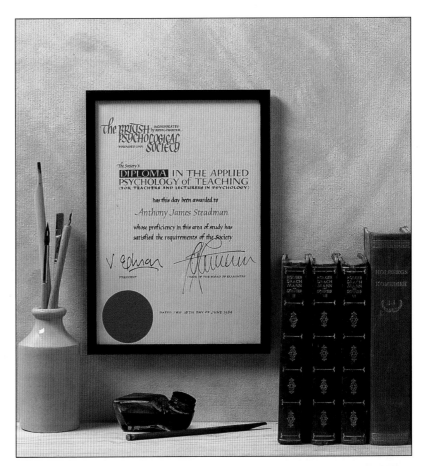

3 On a spare certificate, draw the guidelines in the correct position. Carefully cut out a template to enable guidelines to be drawn easily on the rest of the certificates. Cut along the outside of the pencilled lines, or your guidelines will be narrower than you intended.

4 Draw faint guidelines on each certificate through the template, centre each name strip above the guidelines and write the final version. Allow the ink to dry thoroughly before carefully erasing the guidelines.

Wedding Invitation

A symmetrical or "centred" layout is the usual arrangement for formal invitations. Basic decisions should be made by the client – such as the format (portrait or landscape), whether the invitation will be a single or folded card, the colour, paper and envelopes. It is wise to liaise with a printer early on – the size of available envelopes, for example, will dictate the proportion of your design. The finished, trimmed size should be about 5mm/¹/₄in short of each side of the envelope, with the same allowance below the flap fold.

MATERIALS
pencil
lined paper
metal ruler
pen
brush
ink
paper
craft knife
cutting board
mixing bowl
adhesive
strips of coloured paper
coloured ink or gouache

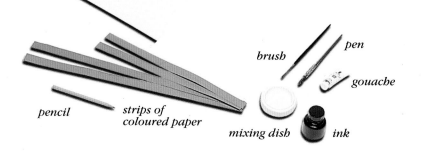

paper

pencil *strips of coloured paper*

brush *pen*

gouache

mixing dish *ink*

metal ruler

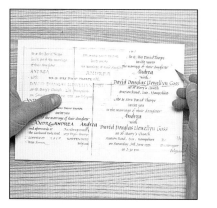

1 Draw out a few roughs, perhaps emphasizing some of the words in capitals or a second colour. Work about "half-size up" – not more than this because fine lines cannot survive too much reduction.

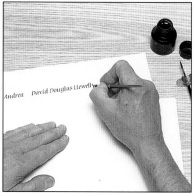

2 A convenient way to centre the lines of writing is to copy out the text, cut the paper into strips and arrange them on a piece of card. Write the larger main lettering first, then the subsidiary lines.

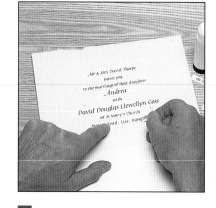

3 Paste up the strips on the card, centring each line. This version may be given to the printer or used as the final rough draft.

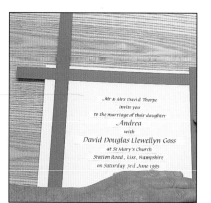

4 Establish the margins using strips of coloured paper to help you visualize the final effect.

5 After the invitations have been printed, add a finishing touch by writing a personal monogram on the front of each invitation.

TIP

The printer will need your work on white paper with the design in intense black. If some lines are to be printed in a second colour, the submitted artwork should still be black, but supply samples of the chosen colour. Other instructions will include the amount of reduction, the number of copies needed and details of the paper and envelopes you have chosen.

Mr & Mrs David Thorpe
invite you
to the marriage of their daughter
Andrea
with
David Douglas Llewellyn Goss
at St Mary's Church
Station Road, Liss, Hampshire
on Saturday, 3rd June 1995
at 2·30 pm

d afterwards at
e Goodwood Park Hotel
ODWOOD
st Sussex

R.S.V.P.
Diestbrugstraat 45
3071 Erps – Kwerps
KORTENBERG
Belgium

Place Cards

People with calligraphic skills are frequently called upon to produce place cards for wedding receptions and other celebratory dinners. Don't be tempted to cut or purchase blank cards of the same size: Francesca Williamson will need rather more space for her name than Ben Fox. Check on the colour scheme for the table setting before selecting white or coloured cardboard and deciding on the colour in which you will write.

MATERIALS
coloured cardboard
pencil
metal ruler
pens
gouache
mixing dish
brush
soft eraser
craft knife
cutting board
scissors

cutting board

cardboard

metal ruler

pens

craft knife

pencil

mixing dish

scissors

gouache

1 Experiment with an appropriately sized pen and its complementary x height before drawing faint guidelines and pencil marks to indicate where the card will be cut into strips. Allow twice this measurement if the card is to be folded and to stand upright.

2 Write each name on the guest list, leaving a suitable space on either side.

3 Use white gouache to add small ornaments on either side of each name.

4 When the ink or colour is thoroughly dry, use a soft eraser to remove the guidelines. Score along the fold lines.

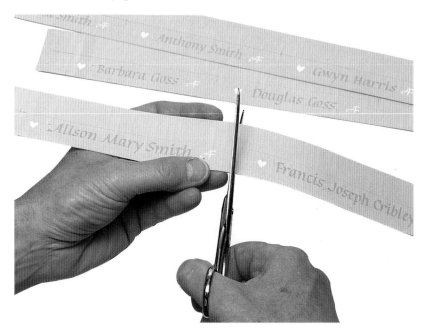

5 Finally, cut the card into strips and divide the names with scissors. Fold the place cards along the scored lines so that they will stand up.

Embossed Thank You Card

Embossed lettering always looks restrained and stylish. Cut chunky letter shapes in a sheet of card to make a template for your own embossed cards.

MATERIALS
pencil
metal ruler
thin cardboard
craft knife
cutting board
adhesive
medium-weight watercolour paper
masking tape
burnisher, bone folder or large
 knitting needle

cutting board *cardboard*

*masking
tape*

*cardboard
for template*

adhesive

pencil

*craft
knife*

*medium-weight
watercolour
paper*

burnisher

metal ruler

TIP
If you wish to use damp paper for better embossing results, protect the cardboard template with a coat of varnish.

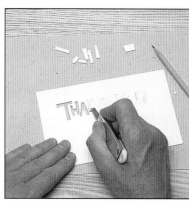

1 Draw the lettering on thin cardboard. A more raised letter is produced by using thicker card, but it is difficult to cut. Using a very sharp craft knife, carefully cut out the letters, retaining the counter-shapes (such as the inside of the letter "o"). It is helpful to rotate the card when cutting curves.

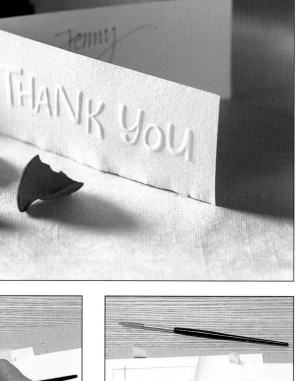

2 Stick down the cut template in reverse on another piece of card, together with the counter-shapes. Draw an outline margin "frame" on to which the paper for embossing will be placed.

3 Cut a piece of fairly strong watercolour paper twice as long as your established rectangle. Place the left half in position and secure with masking tape. Gently push the paper into the letter spaces using a burnisher, bone folder or large rounded knitting needle.

4 Peel back the paper from time to time to see your progress. When the embossing is complete, fold the paper in half to make a card.

Change-of-address Cards

An easy way to produce lots of change-of-address cards is by photocopying your design, not one at a time but four, six or eight at a time. With a little patience, they can be enhanced with a splash of colour after the copies have been made.

MATERIALS
pencil
paper
metal ruler
pen
ink
brush
craft knife
cutting board
adhesive
correction fluid, white gouache or
 poster colour (optional)
photocopier

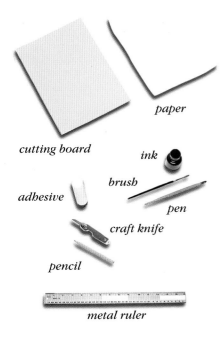

cutting board

ink

brush

adhesive

pen

craft knife

pencil

metal ruler

paper

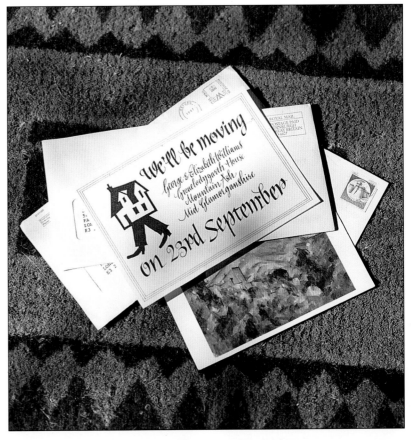

1 Begin by sketching out some ideas on a sheet of paper. Decide on any decoration or motif and establish the size of the card, which will need to fit into a standard-sized envelope.

2 Draw in the top and left-hand margins. Draw and carefully paint the motif in black.

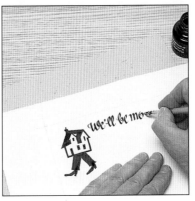

3 Incorporate the lettering in intense black to copy well. You may prefer to write each element separately and paste strips of lettering in place. In this case, use white correction fluid, white gouache or poster colour to cover the edges of the strips, otherwise the photocopier will pick up the joins.

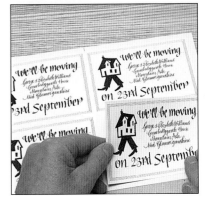

4 When the design is finished, finalize the margins and add a border if appropriate. Indicate where the cards will be trimmed by marking small right angles at suitable points outside the artwork. Calculate any reduction needed to fit a number of copies on to a standard-sized sheet. Photocopy and trim.

Wine Labels

Producing labels for your own or a friend's wine satisfyingly rounds off a home-made vintage. The idea for the design of this wine label came from an old relief carving of a grape harvest, and was drawn to resemble a wood-cut. Photocopy the finished artwork before hand-colouring it.

TIP
The labels can be trimmed a few sheets at a time – not by exerting more pressure on the knife but by drawing it repeatedly along the edge of the ruler. Hold the ruler firmly so that the sheets stay in place.

MATERIALS
photocopier
tracing paper
pencil
cartridge paper
metal ruler
fine black felt-tipped pen or
 drawing pen
lettering pens
ink
brush
A4 paper
adhesive
coloured felt-tipped pens
craft knife
cutting board
wine bottles

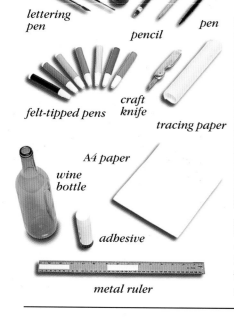

brush *ink* *fine black felt-tipped pen*

lettering pen *pen*

pencil

felt-tipped pens *craft knife*

tracing paper

A4 paper

wine bottle

adhesive

metal ruler

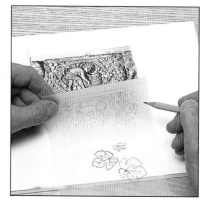

1 Find an appropriate motif for your label and if necessary reduce it to a suitable size using a photocopier.

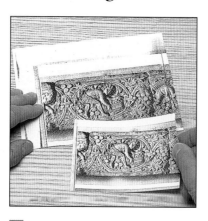

2 Using a pencil, trace the main elements of the design.

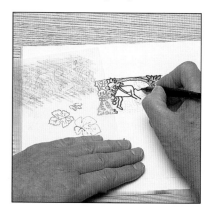

3 Transfer the tracing to a piece of cartridge paper and draw the design with a fine black felt-tipped pen or drawing pen. Add the lettering. Reduce its size on the photocopier if necessary and make four copies.

4 Stick the photocopies on to a sheet of A4 paper. Make small pencil marks to indicate where the labels will be trimmed. Photocopy the required number of labels.

5 Enhance the design by adding splashes of colour with felt-tipped pens. Trim the labels using a craft knife.

6 Stick the labels on to the bottles.

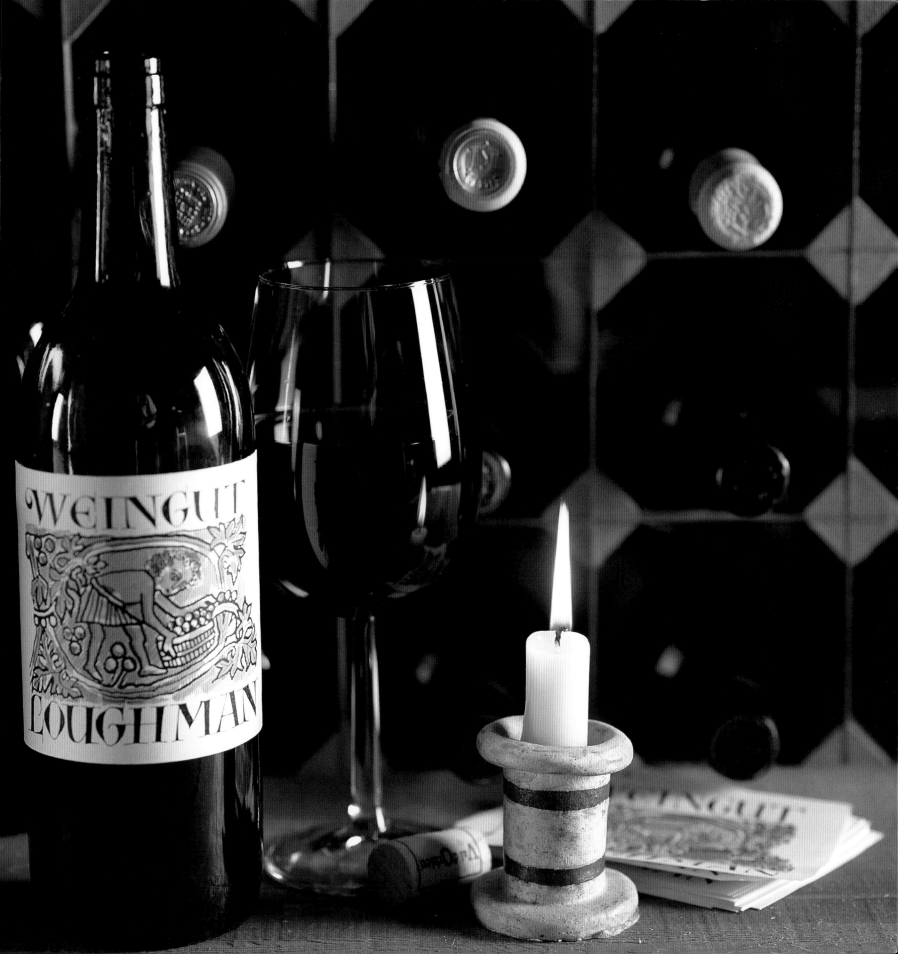

Bookplate

The bookplate proclaims ownership and adds personality to your books. It may be designed to include an individual name or, like this one, with space to add any name. This one is designed for reproduction by a printer. It is drawn as a reverse image because it is easier to draw the letters as "positive" shapes. The blank area is needed for a handwritten name to be inserted. If a reverse image is not needed, you can make copies of your bookplate using a photocopier.

MATERIALS
cutting board
pencil
ruler
cartridge paper
fine brush
ink
pen
designer's gouache
mixing dish

designer's gouache

mixing dish

cartridge paper

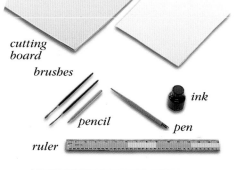

cutting board

brushes

pencil

pen

ink

ruler

1 Rule up guidelines on smooth cartridge paper.

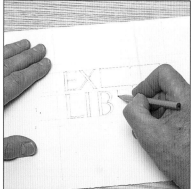

2 Carefully draw the lettering at twice the size of the finished bookplate.

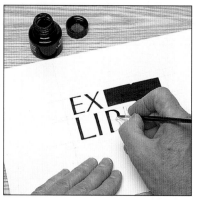

3 Using a fine brush, paint the letters and the book silhouette meticulously in intense black. Select the colours for your design and liaise with the printer.

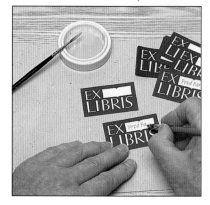

4 Complete the printed bookplates by writing in the owner's name using a lettering pen and designer's gouache.

INSTRUCTIONS TO THE PRINTER:

Reverse image.
Reduce to ½ size but allow for bleed on all sides.
Print 500 in each of three colours (see enclosed swatches).

Bookmark

A personal bookmark makes a thoughtful greeting card: it can be used to express gratitude or an apology, and is a particularly appropriate "Get Well Soon" card for anyone passing the time in bed with a book. A scrap of good hand-made paper is ideal for this project. Check that you can get a suitably sized envelope in which to send the bookmark, or make one yourself.

MATERIALS
coloured paper
pens
designer's gouache
mixing dish
brush
ruler
craft knife (optional)
hole punch
ribbon

mixing dish

ribbon

coloured paper

hole punch

designer's gouache

brush

pens

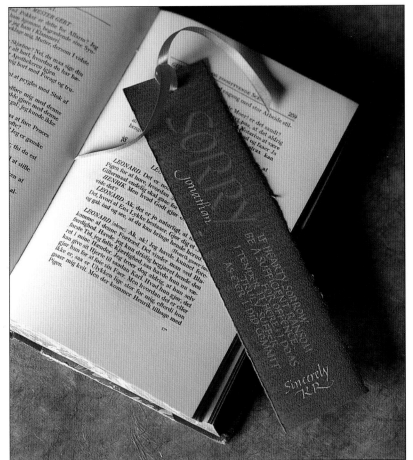

1 Write the main message using a broad nib and designer's gouache. Work from a design rough.

2 Use a smaller nib and a contrasting colour to write the smaller words. Allow the design to develop as you go along, letting spaces dictate the size and layout of extra wording.

3 When the message is complete, decide on the lower margin and tear or cut the bookmark to size. Preserve the deckle edges of hand-made paper where possible.

4 Punch a hole in one end and thread a short piece of ribbon through it.

A Lino-cut Party Invitation

Lino (linoleum) can be used to make a good substitute for a wood-cut, and of course it is much easier to cut (especially if it has been warmed on a radiator). You can use a sharp craft knife and a gouge, but other lino-cutting tools are easily available. This invitation uses a "black line" technique, in which the lettering is printed and the background cut away. Don't forget to cut your design in reverse. With experience, you can draw the letters straight on to the lino in reverse, but do check them in a mirror before you cut.

MATERIALS
HB and 4H pencils
paper
ruler
tracing paper
white pencil
craft knife
lino (linoleum)
lino-cutting tools
black printing ink
glass sheet
palette knife
ink roller
bone folder
adhesive
coloured cardboard

ink roller

black printing ink

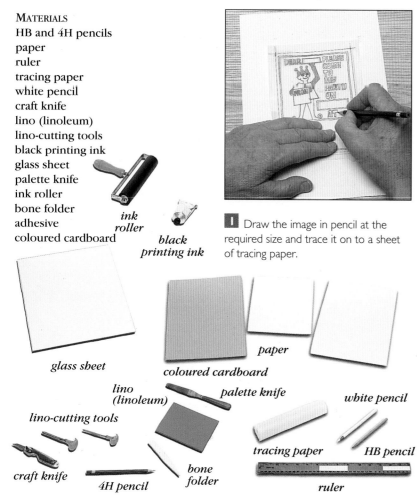

1 Draw the image in pencil at the required size and trace it on to a sheet of tracing paper.

glass sheet

coloured cardboard

paper

lino (linoleum)

palette knife

white pencil

lino-cutting tools

tracing paper

HB pencil

craft knife

4H pencil

bone folder

ruler

2 Scribble with white pencil over the front of the tracing, turn it over and place it on a piece of lino (linoleum). Using a pencil, transfer the image on to the lino.

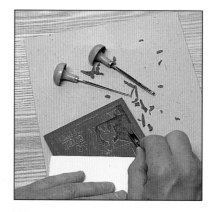

3 Use a sharp craft knife and lino-cutting tools to remove the background areas of the design, making sure that you do not undercut the printing surfaces. Always keep your supporting hand behind the cutting tool.

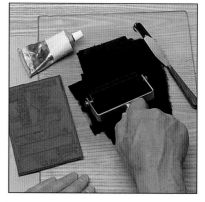

4 Squeeze a small amount of black printing ink on to a glass sheet or similar smooth, non-absorbent surface. Spread it out with a palette knife. Roll and lift the ink roller to spread the ink evenly.

TIP

Water-based printing inks can be cleaned up easily with water, but tend to dry quickly during the process of printing. Oil printing inks will remain workable for longer, but the cleaning up will require white spirit or turps substitute.

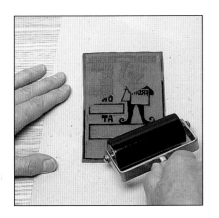

5 Ink up the surface of the lino block using the roller. Cover the corners first and avoid rolling over the edge. Do not over ink.

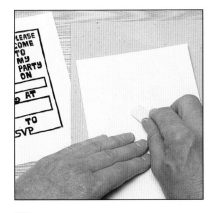

6 Place a piece of fairly thin paper over the inked surface and burnish with a bone folder. Pull up the corners to check on the print quality. Remove the print and leave to dry before mounting it on coloured cardboard.

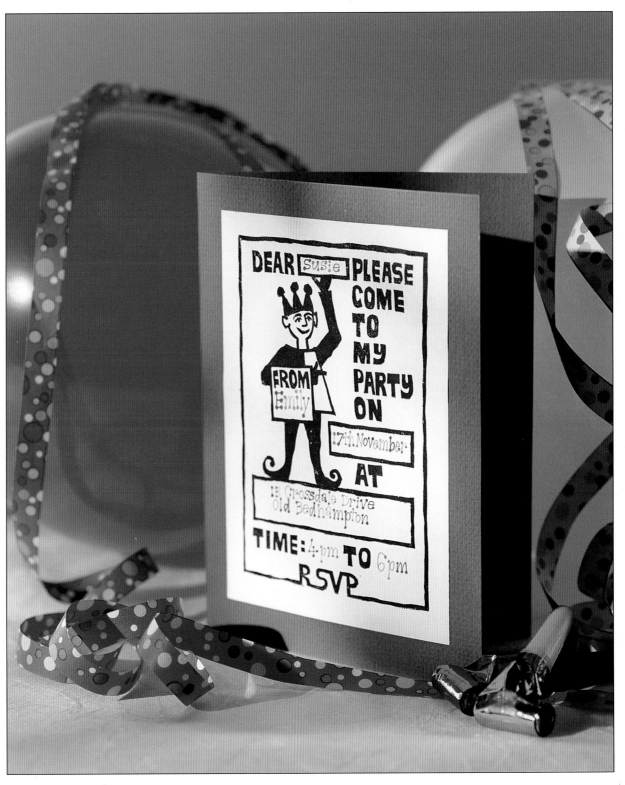

Multicoloured Lino-cut Birthday Card

This lino (linoleum) cut uses a "white line" technique: the lettering has been cut away and the background will print. The lettering is cut by making inward sloping cuts so that the insides of the letters "pop" out. Make the small white dots with a twisting movement of a small round gouge. With careful handling of the roller, you can ink the block with several colours at once, to produce a multicoloured effect. When the card is complete, insert the date in the balloon and write in the recipient's name by hand.

MATERIALS
HB and 4H pencils
ruler
paper
tracing paper
white pencil
lino (linoleum)
craft knife
lino-cutting tools
coloured printing inks
glass sheet
palette knife
ink roller
bone folder
adhesive
coloured cardboard

ink roller

lino (linoleum)

lino-cutting tools

1 Draw the design in pencil and trace it on to a sheet of tracing paper.

coloured cardboard

tracing paper

paper

white pencil

glass sheet

palette knife

coloured printing inks

craft knife

HB and 4H pencils

bone folder

ruler

2 Scribble over the front of the tracing with a white pencil, turn it over on to a piece of lino (linoleum) and transfer the drawing using a hard, sharp pencil.

3 Use a sharp craft knife and lino-cutting tools to remove the areas of lino which are not required to print. Remove small areas with a "V" shaped cut and do not undercut the design.

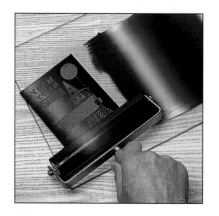

4 Squeeze three worms of different coloured ink on to a glass sheet. Spread them carefully in one direction only using a palette knife, then roll evenly with an ink roller. Ink up the lino block in a consistent direction. Do not over-ink.

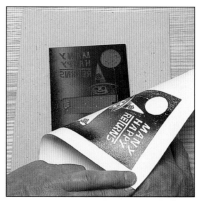

5 Place a sheet of paper over the inked-up block and burnish with a bone folder to transfer the image. Remove the print and allow to dry before mounting it on coloured cardboard.

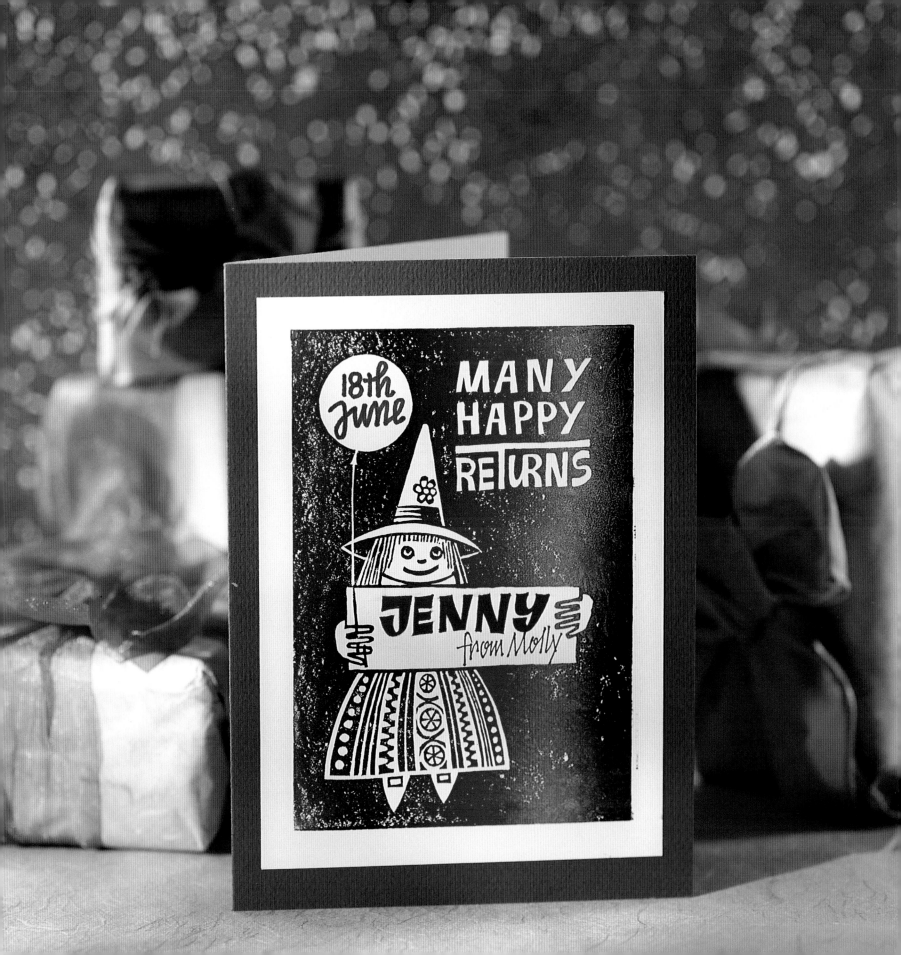

Christmas Cards

Calligraphy is ideal for producing Christmas cards, whether you make them individually, photocopy your design or have them professionally printed. Writing individual cards is time-consuming, but you can keep the wording short. You will be able to use colour freely and original cards are always highly appreciated. Aim to make your cards fit standard-sized envelopes.

If you decide to have a card printed, it is worth considering a two-colour run where "over-printing" will produce a third colour. You will need to draw the two different coloured elements of the design separately (in black) and make the drawing for the second colour on an overlay to allow for accurate registration. For this card, the printer has been instructed to reverse out the lettering so that the background will print.

MATERIALS
pencil
paper
coloured pencils
ruler
drafting or tracing paper
drawing pen
fine brush
ink
cardboard

paper

fine brush

drawing pen

ink

drafting or tracing paper

pencil

ruler

TIP

Ask the printer how you should submit your work, and ask to see samples of colour combinations. Your instructions must include the reduction and details of images that will have to be reversed.

1 Begin by drawing some roughs. If you are aiming for an "overprinting" effect, experiment with coloured pencils. Establish the size of the lettering.

2 Use a pencil to draw guidelines for the lettering on drafting paper or best quality tracing paper.

3 Using a drawing pen, brush and black ink, draw the first image of the figures and tree. Determine the outer dimensions of the card and assess reduction.

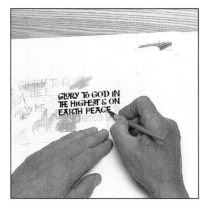

4 Draw the lettering using a fine pen and black ink. The drafting paper can be placed over your initial rough for guidance.

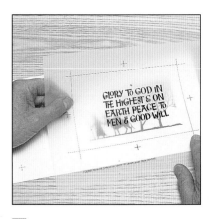

5 Place the lettering over the first image, decide on its position and trace the marked edges of the card on to the overlay. Draw registration marks on both sheets just outside the dimensions of the card.

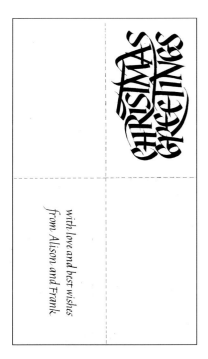

A greeting on the inside of a card can be photocopied or printed at the same time as the outside if it is double-folded. Paste up the artwork like this.

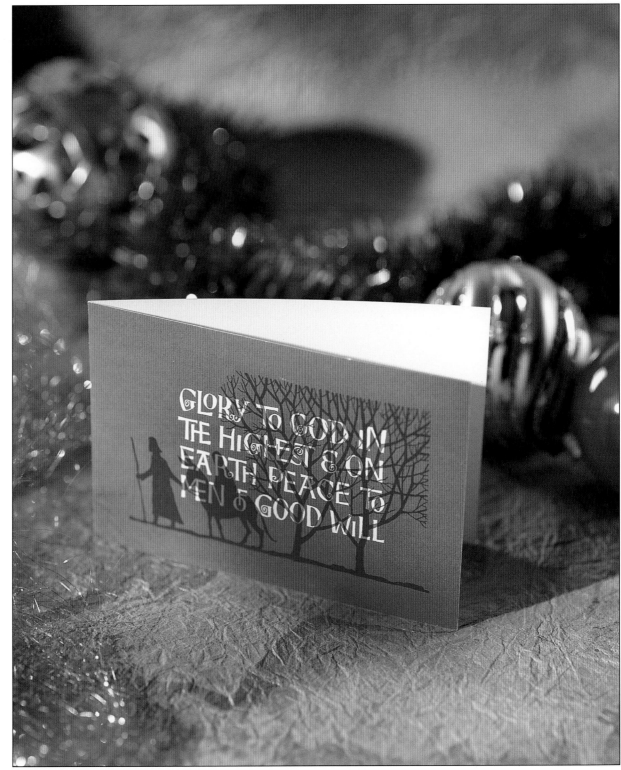

Acknowledgments

The publishers would like to thank the following people for permission to reproduce works contained within this book. Andrew Johnston: a writing sheet of Edward Johnston p28; Gresham's School, Norfolk: album p30; Daily Telegraph: Leopold Kohr quotation p41; The British Library: detail from Psalterium Romanum cum Canticis p43; The Golgowooza Press 1982: Untitled poem by Kathleen Raine p44; the Bodleian Library, Oxford: part of the Ormesby Psalter p46.

The author and publishers also wish to thank the calligraphers listed below for permission to reproduce their work. Joan Pilsbury pp 15, 33TL, 37TR; 45TL; John Shaw pp 26T, 27B; Tom Perkins p27T; Ida Henstock p30; Peter Halliday p31; Mark Smith p37L; Kennedy Smith p42; Polly Morris p44R; Ieuan Rees p46; Frederick Marns (copperplate alphabet) pp 50, 51, 52. Julian Waters p53R; Celia Kilner p63; Meinrad Craighead p66.

All other illustration and calligraphy is by the author.

T=top, B=bottom, R=right, L=left

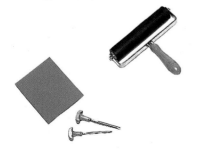

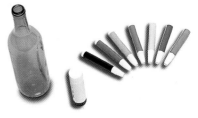